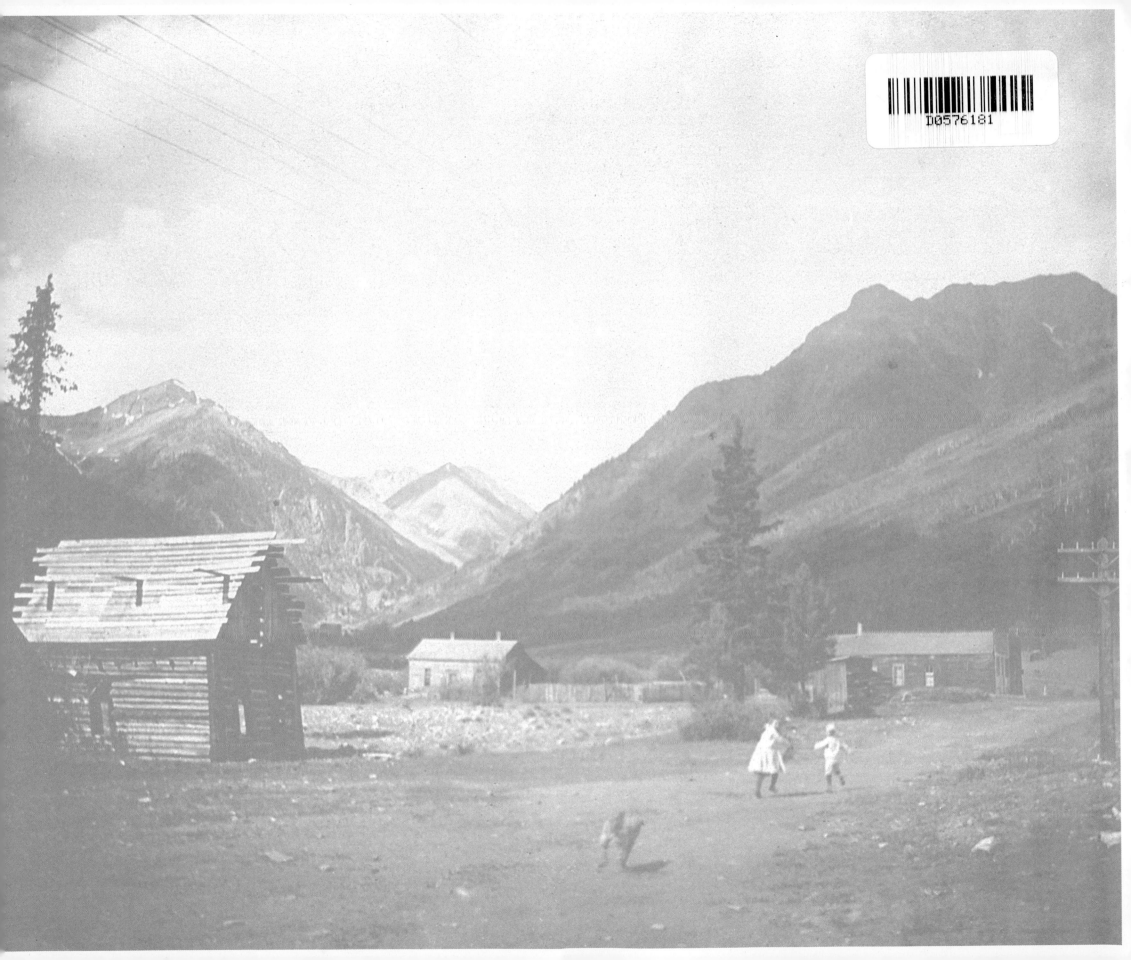

# I LOOKED IN THE BROOK AND SAW A FACE

## Images of Childhood in Early Colorado

Text by

### DAVID N. WETZEL

Photos selected and edited by

### MARY ANN McNAIR

COLORADO
HISTORICAL SOCIETY

From the Collections of the Colorado Historical Society

WESTCLIFFE PUBLISHERS

www.westcliffepublishers.com

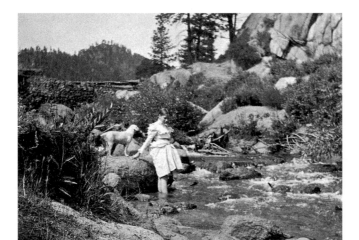

## THE BROOK

I looked in the brook and saw a face—
Heigh-ho, but a child was I!
There were rushes and willows in that place,
    and they clutched at the brook as the
        brook ran by;
And the brook it ran its own sweet way,
As a child doth run in heedless play,
And as it ran I heard it say:
        "Hasten with me
        To the roistering sea
    That is wroth with the flame of the morning sky!"

I look in the brook and see a face—
    Heigh-ho, but the years go by!
The rushes are dead in the old-time place,
    And the willows I knew when a child was I.
And the brook it seemeth to me to say,
As ever it stealeth on its way—
Solemnly now, and not in play:
        "Oh, come with me
        To the slumbrous sea
    That is gray with the peace of the evening sky!"

    *Heigh-ho, but the years go by—*
    *I would to God that a child were I!*

**Eugene Field**, *Love-Songs of Childhood*
In *The Works of Eugene Field*, Vol. 4 (1901)

---

Eugene Field (1850–1895), commonly known as the "Children's Poet," worked as a reporter in Denver in the early 1880s. Among his most memorable poems are "Wynken, Blynken, and Nod" and "Little Boy Blue."

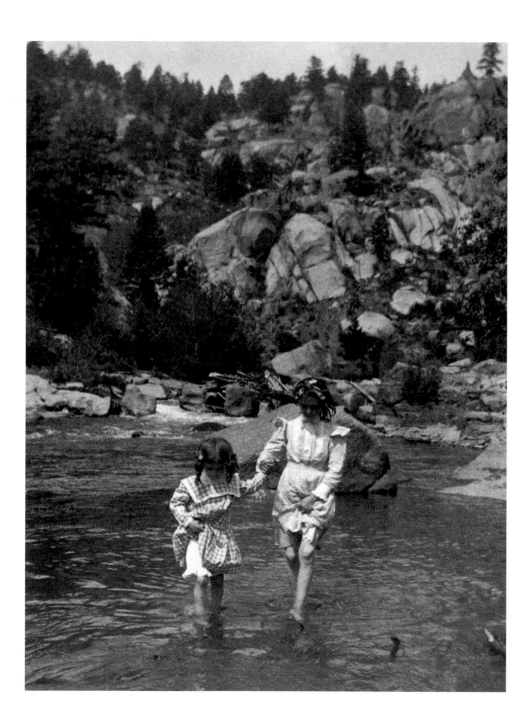

Two daughters of John L. Jerome. **JOHN L. JEROME,** 1902

# CONTENTS

# PREFACE

The idea for this book was born more than 20 years ago, when William F. Miner, then director of exhibits at the Colorado Historical Society, came across some 35,000 glass-plate negatives of portraits made between the 1890s and the 1930s in the Trinidad portrait studio of Oliver E. Aultman. As Miner and his wife Donna surveyed the plates, they realized that nearly one-fifth of the collection was images of children. These portraits, Miner first thought, could serve as the basis for a large-scale, multicultural exhibit on children in early Colorado—one that would include toys, clothing, schoolwork, books, and documents about children's lives.

But then Miner discovered a series of photographs that changed the whole course of the exhibit. They depicted a young boy getting dressed up in his Little Lord Fauntleroy outfit prior to having his portrait made. The scene, though not candid, was so remarkably unrehearsed that Miner sent photocopies to his colleagues at the Smithsonian Institution, asking if they had ever seen this kind of "pre-sitting" event in studio portraiture. They hadn't—and they were as taken by the freshness of the images as he was. From this discovery, Miner revised his plan for a traditional exhibition about *children* in Colorado to an innovative exploration of *childhood*, based primarily on what photographs alone could reveal of childhood experience, including the typical trip to the photographer's studio for a portrait.

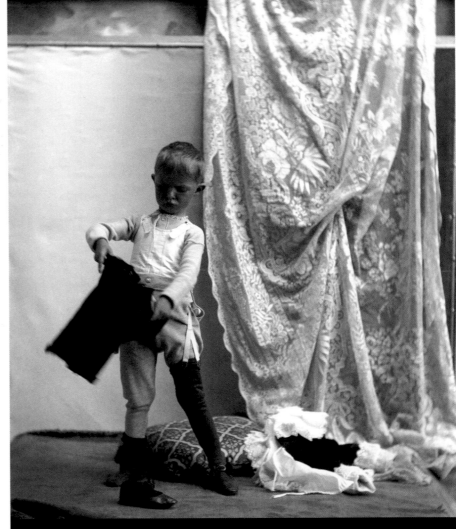

BOY DRESSING UP FOR PORTRAIT (BUD DAVIS FAMILY). OLIVER E. AULTMAN, 1896

In June 1981, as a new editor at the Society, I was asked to spend a year with Bill Miner's exhibits team to interpret and help produce a series of exhibitions on Colorado history, a major undertaking that would fill nearly 30,000 square feet of gallery space at the Colorado History Museum. My first assignment was the childhood exhibit, so I went right to work preparing a list of books, articles, and memoirs I would need to consult for such a daunting subject. On my second day on the job, however, Miner noticed a few of the books I'd checked out of the library and said: "Take them back. You won't need them." Then, he placed on my desk a stack of

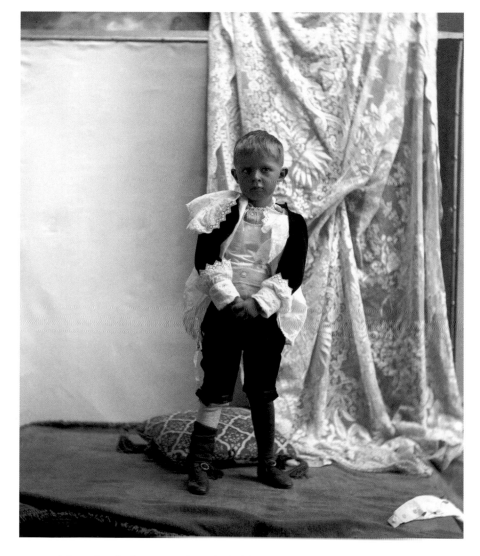

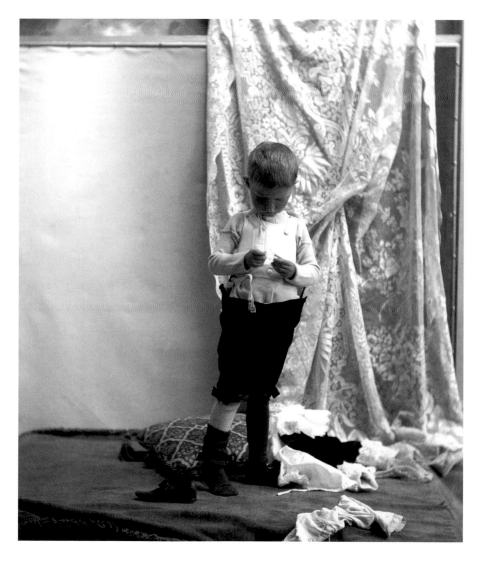

several hundred photographs of children from the Aultman studio and other Society collections. "Here's where you get your information," he said, "by looking."

It was a shock—and a challenge. It was much like being asked to determine the speaker, place, time, and historical context of the Gettysburg Address using only the words of the address itself. That had been one of my assignments in graduate school, a lesson in the use of internal evidence. But in this case, there was no historical event, set of outside conditions, or precedent to work from—or toward. The lives of children are

distinctly individual, made up of thousands of episodes, feelings, interactions, adventures and misadventures, and changes in life. How would it be possible to capture these lives in a way that expressed childhood experience—by gender, by age, or by ethnic, racial, or national background, and through time?

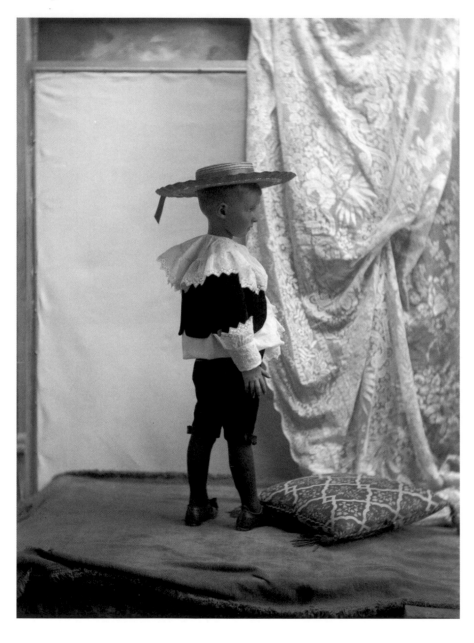

It wasn't. However, what the photographs *did* reveal was the obvious—and nearly universal—bond between parents and children, of children in families, and of children as friends, as well as the sense of how children live in the world, whether inside the home, at school, or outside in their own familiar landscapes. The vignettes that accompany these themes only scratch the surface of childhood's character across generations, but they are meant to suggest it, not to analyze or describe it.

Along with this challenge, Miner had another task for me, though not as difficult as the first had been. In contrast to the largely inaccessible world of the unknown children depicted in the exhibit, he planned to include the story of one girl's life, based on childhood objects that came to the Society in a family trunk in 1975. Aside from the girl's name, Irma Bartels, and donor information provided by her nephew, Arthur F. Hewitt, Jr., nothing was known about her. In keeping with the approach I had taken with the photographs, Miner wanted to see how much of Irma's life and childhood experience (cut short by her sudden death at age 12 in 1901) could be drawn from the objects in her trunk. In this instance, however, he told me I could expand my research to include "outside" documents such as newspaper articles, census data, city directories, and other kinds of historical resources (though, I still believe he regarded this kind of broader research as cheating).

Trained as a designer in the internationally renowned office of Charles and Ray Eames, Bill Miner came to the Colorado Historical Society from the Smithsonian Institution, where he had produced the widely recognized 1976 American Bicentennial exhibition. His approach to historical objects—artifacts, photographs, documents—bordered on the sacred, and he threw away traditional guidebooks and practices on the interpretation of objects. As a result, the Colorado history exhibitions of 1982 became one of the finest, though quiet and little-known, examples of experimentation in historical interpretation.

The childhood exhibit was only one of many that addressed different themes and subjects—but with the *object* as the starting point of wonder, curiosity, and exploration. Interpretation could go in any direction, but it had to reflect the object's integrity and its reasonable place in the historical world we created around it. At the core of any statement we made about an object was not only what it was and said to its onlooker, but what it wasn't—in short, a reliable assessment of the object itself as a witness to history.

For this reason, a remarkable set of photographs did not go into the childhood exhibit, even though they express the comfortable, well-to-do life Irma's family led. The high-quality furnishings, throw rugs, works of art, sheet music, and items of culture were surely among those she looked upon and touched. But, despite the fact that Irma lived in many houses in Denver's Capitol Hill area, the house itself can't be identified. The home pictured here, like most of the Bartels' residences, has probably been torn down, and it may have even been purchased after Irma's death.

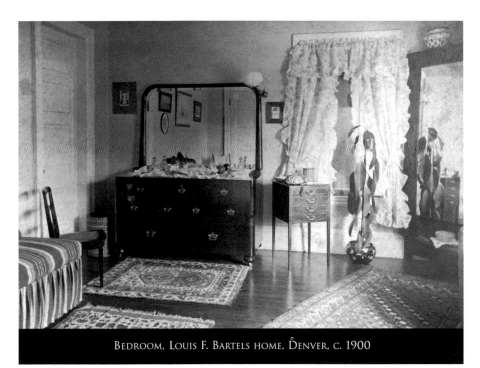

BEDROOM, LOUIS F. BARTELS HOME, DENVER, C. 1900

In other words, we can't be sure Irma ever walked these rooms. But, even so, as she grew up, she surely touched, looked upon, and identified with the furniture and other objects that appear here. They show us that she was indeed a privileged child of the time, but they also invite us to visualize her in these settings and perhaps understand how barren the surroundings appeared to her parents after her death. Her sister Elsa cherished Irma's memory so much that when she inherited the trunk years later, she would not allow her own children to open it. When the exhibit went on display, Arthur Hewitt, Jr., told me he had never before seen the trunk's contents.

In spite of all the telling objects in Irma Bartels' trunk, only one spoke directly of her innermost experience. It is a small, blue sheet of paper tied with a pink ribbon that bears, in her own handwriting, the words, "Blanche Walsh, 722 Clarkson Street." Denver city directories indicate that no Blanche Walsh ever lived at 722 Clarkson Street, and none of Irma's friends or any members of her immediate or extended family had that name. This mystery sat as an unsolved puzzle during the months I investigated her life. But when I thought long and hard on it, shortly before the exhibit opened, I realized it was a product of Irma's active imagination. Indeed, the *World Almanac* for 1982, under Noted Persons of the Past, confirmed that Blanche Walsh was a well-known American actress at the turn of the 20th century. Young Irma, in Denver, admired and dreamed about Walsh, just as children have always done with their idols.

For 20 years, the experimentalism of the childhood exhibit worked against its adaptation into book form. The prevailing opinion seemed to be that images of children should express a survey of childhood in Colorado with social commentary, not a photographic study with intimations of common childhood experience. In John Fielder and Westcliffe Publishers, however, the Society found a team of people who were sensitive to the message these images portray—and willing to see that they reached a wider audience.

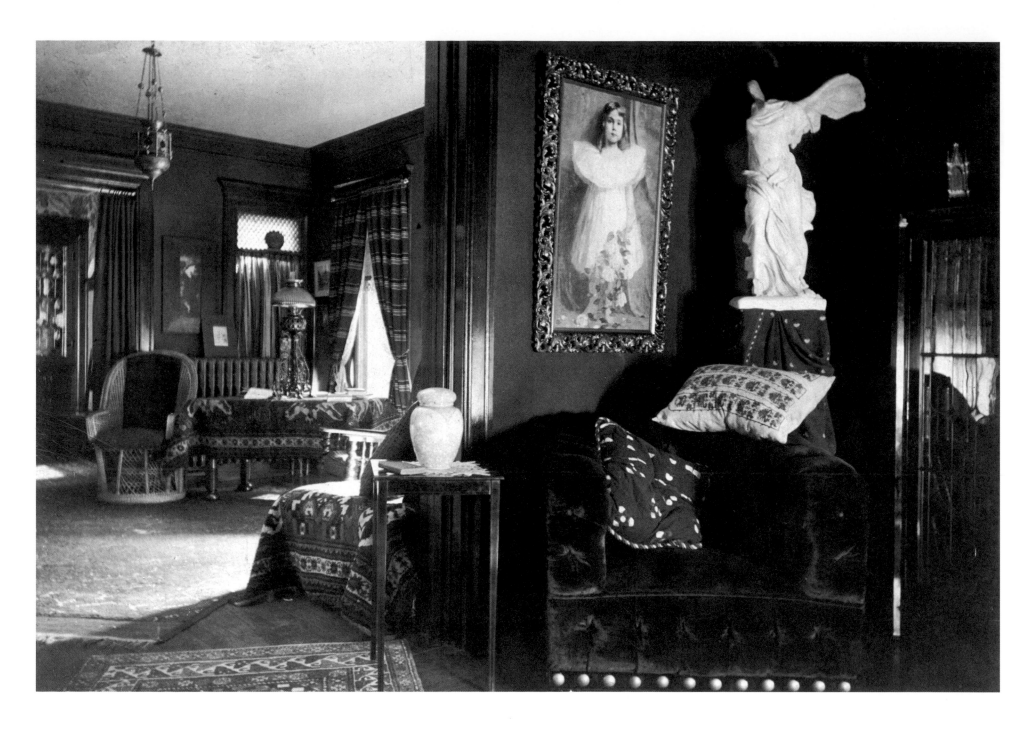

PARLOR, BARTELS HOME, DENVER, C. 1900

Many people have contributed to this book over the past 20 years, most notably Bill Miner, who originated the idea in 1981, and Donna Miner, who found and passed along many photographs. It was Donna who initially offered the solution to the mystery of the two Rifle, Colorado, church photographs discussed in the Introduction. I will always be indebted to them for their spirited guidance as the major themes and vignettes for the childhood exhibit, and for this book, took shape.

Others, from the outset and later, gave valuable advice, usually in the form of statements like: "I don't think my mother was ever like that," or "This is from a boy's perspective, not a girl's," or "I'm not sure this point of view works." The key members of that long-ago focus group were professional historians on the exhibits team and at the Society: Dr. Maxine Benson, then Colorado's state historian; Dr. Judy Gamble, my colleague in publications; and Dr. Donald English, a specialist in photographic history. At home, I received valuable comments from my personal professor, Dr. Jodi Wetzel, who looked over many drafts.

During the ensuing years, the most important critic was my former graduate thesis advisor, Professor Hal Moore. A teacher, fiction writer, and mentor, Moore directed the creative writing program at the University of Utah during the 1960s. Aside from his wisdom, he shared with me his recollections of growing up in Montrose, Colorado.

I also offer my sincere thanks to Dr. Modupe Labode, the Society's chief historian, and to Eric Paddock, curator of photography, for their sound advice and suggestions for improving the text. Special thanks goes to my longtime friend and colleague, Dr. David Fridtjof Halaas, former chief historian at the Society and now museum division director for the Historical Society of Western Pennsylvania, whose support for the project has been solid throughout the years.

Other essential support came from the Society's past and present library staff, including Kay Engel, who did much to facilitate the work of the exhibits team years ago, and current librarians Rebecca Lintz, Barbara Dey, and Debra Neiswonger. Judy Steiner, the Society's associate curator of photography, also provided invaluable assistance.

Martha Dyckes, director of the Society's Division of Interpretation, recognized the book's potential and worked hard to shepherd it through months of plans and discussions while it competed against other Society projects. Both her faith and tenacity, I hope, have finally been rewarded.

Last—and, of course, most important—Mary Ann McNair, my colleague in this venture, reviewed thousands of photographs in the Society's collection (enough, altogether, to fill two or three books) and selected those that demonstrated a diversity of children, settings, experiences, and themes. But in the final selection, her discriminating eye for the quality of an image and the human character it represents is evident throughout the book. I'm also deeply indebted to her for helping shape the text and images into a unified work.

David N. Wetzel
April 2002

# INTRODUCTION

Childhood is a personal possession. It's a private history that can never be fully known by anyone but the one who lived it. Even when the dates and names in one's own past have been forgotten, the images of personal childhood are imprinted on the mind with direct scenes of unshakable veracity. The images come down to us through recollections captured in sight, sound, smell, taste, and touch—and, like the tea and madeleine in Marcel Proust's *Remembrance of Things Past,* they can be triggered by contemporary associations that immediately take us back to a forgotten or buried event.

Rarely are these events and memories revealed in photographs, for they are largely accidental. They can be as commonplace as the memory of walking down a certain street at a particular time of day when you were 10 (or maybe 12) and realizing the world was quite all right, and nothing more than that. Or, they can be of singular events that recur in memory over and over again, triggering emotions of fear, shame, satisfaction, anxiety, or any number of other emotions that form the internal record of our lives. They belong to the private world of childhood, and no photographer—thankfully or regretfully—was present.

But, even though they don't touch our private, internal lives, photographs do reveal the past as almost no other medium can. Family albums are filled with memories precisely because photographs show more than people—they capture every object in the scene. Imagine taking a pair of scissors (or a software photo-editing tool) and removing everything from a family photograph but the human subjects. The result would be timeless, but empty of history. By certain physical characteristics of age and dress, for example, the photograph of a mother and daughter manipulated in this way might be traced to a particular time, place, or event—but it would have little or no mnemonic meaning or power for us as viewers. The casual and accidental items in a family photograph catch our eyes and draw us inevitably into the memory. The scene, let's say, is a bedroom, where the mother and daughter are sitting on a turned-down bed. Although the book they're looking at can't be identified, another is lying on the bedspread. It's a large book with bears on the cover, the very first book you remember reading by yourself . . . and so on.

This experience is not history as we generally use that term, but it *is* an image from the history of childhood. The book, the bedcovers, the child's heavy nightgown, and the mother's clothing—along with the room's furnishings, objects, *and* the type of photograph taken—all become a document of a time, a place, and a social or cultural situation. If we were to manipulate the photograph in the opposite way—that is, to *remove* the human subjects—we would still be able to extract many essentials of social history separate from the personal connection we might have, or want to have, with the mother or daughter in the photograph.

The power of photographs as documents of history draws upon both elements—the human subjects and the surroundings in which they appear. Yet a gap often falls between the two, especially if the people in the

photograph are unknown to the beholder. They can easily become part and parcel of the scene, elements within a larger picture of social life, similar to human figures within an Impressionist painting of the seashore or a cityscape. We want to be there, in fact want to know them, but most of all we want to embrace the whole as a direct window to the past. The subjects' identities are subsumed within the painted experience that we want to grasp.

At its best, social history can do the same thing—and photographs enhance the sense of *being there*, whether it's on a Newport beachfront of the 1890s or in the post–Civil War South. Through narration, pictorial images, and documents, social history teaches us what life was like in certain historical circumstances—and, when we are lucky, the picture includes the life experiences of actual people told through anecdotes, recollections, and personal testimony.

All too often, however, social history turns the powerful medium of photography into a document that merely serves the point of the narrative, the description, or the idea. Used in this way, photography becomes little more than illustration or example, as do the human figures in the context of the photograph-as-document. We look at the images, but we really don't see them as if we had come across them for the first time. Someone else has already done that, and for a well-defined purpose.

The point of this book, in contrast, is to let the images (as much as they can) tell their own stories of childhood experience. No object, whether a painting, photograph, building, or artifact, can do that alone— at least to the satisfaction of the person who looks upon it. Every object poses unanswered questions and curiosities that, if the object is worth examining in the first place, lead to multiple interpretations. Nevertheless, these photographs and many like them were the starting places for building a picture of childhood in early Colorado, and they were the sole basis for whatever that interpretation would become. The same is true of the Irma Bartels story, derived from previously undisclosed items in her trunk of childhood treasures.

This is not, then, a social, historical, or cultural study of childhood. But it is a reflection on childhood experience, drawn from an evocative collection of historical photographs and objects that pose their own problems of meaning and interpretation. If you take away our accumulated knowledge about childhood as a stage in human life—including scholarship in history, sociology, anthropology, and psychology, along with evidence from popular history and information based on general reading— how do you make sense of images depicting children in their childhood settings? The process is exactly the same as reading a poem without reference to anything that has been said about it, about the poet, or about the context in which the poem was written.

The lack of reference, basically, is how most people approach poetry and photographs—unless the photographs are of one's own childhood experience. All the information immediately relevant to the photograph or the poem is contained within it. Perhaps this is why historians of photography say that photographs are "made," not "taken." For, instead of offering a passive, mechanically shuttered glimpse of what we assume to be the real world, the photographer, consciously or subconsciously, actually shapes the image. In this respect, a casual snapshot is "made" quite as much as a professional portrait or landscape photograph, though usually not with the same degree of skill or artistry.

Family members looking over their own albums know the rudiments of this principle instinctively. Over and over again someone will ask, "Who was taking the picture?" "When was that?" or "What was going on there?" Our interest in images of familiar scenes and people nearly always extends beyond the information in the photograph itself to encompass the identity of the photographer, the purpose of the photograph, the situation and setting, and memories associated with the event. By way of question and answer, we fill in the very large gap, the wider reality of recollection and experience, that makes the photograph a living document of

our past. Only then, typically, comes analysis and interpretation: "Look at Mother's face—she seems so sad!" Or, "See that cast on Uncle Henry's foot? He got drunk and fell down the stairs." Or, "That must have been Thanksgiving Day—there's a turkey leg on the table behind Jennifer."

However prosaic or personal, the interpretation of family photographs applies the same knowledge, inference, and deduction that social historians use in their work. The difference is that social historians—or any researcher who studies the past through photographs—must rely almost exclusively on the visual clues in the image to fill in the context beyond its edges. The child in this photograph, made in the O. E. Aultman studio in Trinidad, Colorado, in 1897, is uncommonly solemn. But she is not alone, for her unseen mother, and perhaps father, are most likely unhappy, too. Dressed up as an angel—for that's how they regard her—she might have been shy, ill-tempered, and spoiled, or frightened by the unfamiliar surroundings of the studio and its equipment. No doubt her parents are trying to cajole her into proper angelic behavior, which could be making things worse.

Certain key words in the previous paragraph—"perhaps," "most likely," "might have been," "no doubt," and "could be"—demonstrate uncertainty about the events of this real-life episode. The qualifiers hedge the reality of the situation, and historians are quick to criticize this kind of speculation when documented facts are absent. The truth of the matter could be altogether different: the parents might have seen the irony in an unhappy angel and asked Aultman to take the shot, or he might have acted on his own. We cannot know with certainty what motives led to the shaping of this photograph, but we have no doubt that the child is downcast and that any one of these explanations is reasonable.

Suppose that this young girl, in old age, described the photograph—and the event—to her grandchildren. Now the truth comes to light: she was unhappy because her older brother, who had already been photographed, was teasing her. In fact, despite her mother's scolding him and sending him out of the studio, the episode was so traumatic that she

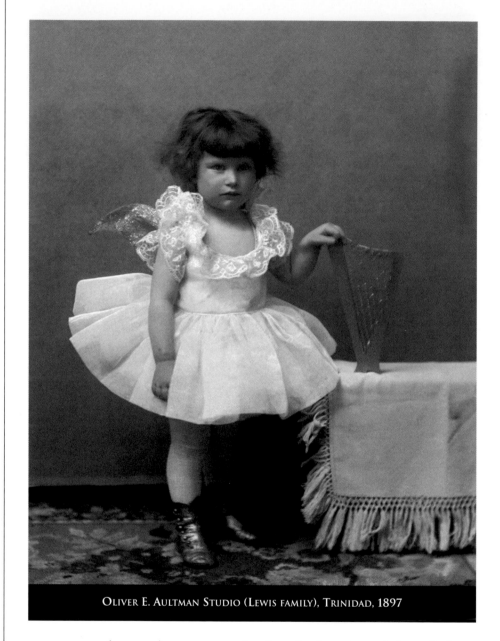

OLIVER E. AULTMAN STUDIO (LEWIS FAMILY), TRINIDAD, 1897

never wore the angel costume again. But she kept it with her all these years—and there it is, out from the closet, as good as new. Such stories make the bond between generations of families, and their appreciation of the past, unbreakable.

As strangers looking at this family photograph, however, we have no firsthand recollections from the child-turned-grandmother, no angel

costume, and no evidence of a taunting brother or angry mother. Does it then become an image without historical or personal meaning? Not at all. It expresses three essential elements—the child, the setting, and the implied context of the image. The child's emotional state is self-evident, and her costume demonstrates not only one kind of social aspiration for little girls, but also her parents' encouragement or acceptance of that self-image. The setting, props, and backdrop of the studio (lacking other evidence) date the photograph to well before World War I. The formality of pose and posture differs significantly from the more casual, spontaneous, and intimate portraits of children today.

The third element, implied context, warrants a bit more discussion, and rests on more than this image alone can convey. Aultman's studio, which occupied the second story of a building on Trinidad's main street, was quite large, dominated by an imposing camera that moved back and forth on tracks. A private dressing room adjoined both the waiting room and the studio, so family members could wait comfortably until the subject of the portrait emerged in best-dressed form.

But, whatever the size of the studio or how it might be equipped, a portrait session with children—now as then—involves planning, a set of expectations about behavior, and a cluster of decisions and emotions that the formality of the event produces. Both for parents and children, it raises the emotional stakes of everyday life in the way that special holidays, birthdays, weddings, or other rites of passage do. Anything can go wrong— and, in this case, it did. The mystery is why Aultman captured it.

In fact, it is not a mystery. We know why—with or without concrete evidence. The small, serious angel is endearing. It's the kind of image a good photographer such as Aultman would have regretted not having captured and saved for his own collection, even if the parents hadn't ordered a print. And it further tells us that the child, even if she were being obstinate or cantankerous, did not unsettle him even if she did her parents.

How do we know the implied context of a photograph is the truth? Or the whole truth? We don't. We rely on our own experience, judgment, and knowledge of human behavior to fill in the picture beyond its edges. The application of all these skills, while not strictly empirical or scientific, *is* consistent with the historical method. Even when historians look at primary documents such as letters and journals, they must make inferences based on their understanding of human character and motives—in short, to read between the lines. But it often takes weeks, months, or years of careful study to make the right inferences from a document or a photograph within its larger context. Looking at a single studio portrait of a child with a dog might easily lead us to make an unwarranted assumption about the child, especially if we didn't also know that the dog, the photographer's prop, appeared in many other photographs of children.

But there is little we cannot easily grasp about childhood in this next photograph of a young boy enjoying the chaotic aftermath of a train wreck (page 14).

Oblivious to the passengers, rescue workers, and others around him—and quite unmindful of the injuries or death that might have resulted from the disaster—he flashes a smile, full of his pure delight in the adventure, at the photographer. For the moment, he is caught up in the excitement and novelty of the event—perhaps thinking, as he realizes that he is the center of the camera's attention, what he will tell his friends about the wreck. And, for that matter, perhaps aware of the importance and prestige he will gain from that telling.

We cannot know what happened to him afterward, whether a moment later a man might have grabbed him up and sent him to help move some track, or shouts from a distance drew him to the sight of a crushed body. But from our own experience of childhood—not in every case, and not necessarily up to this level of drama—we can relate to the disconnection between the devastation and the boy's enjoyment of it.

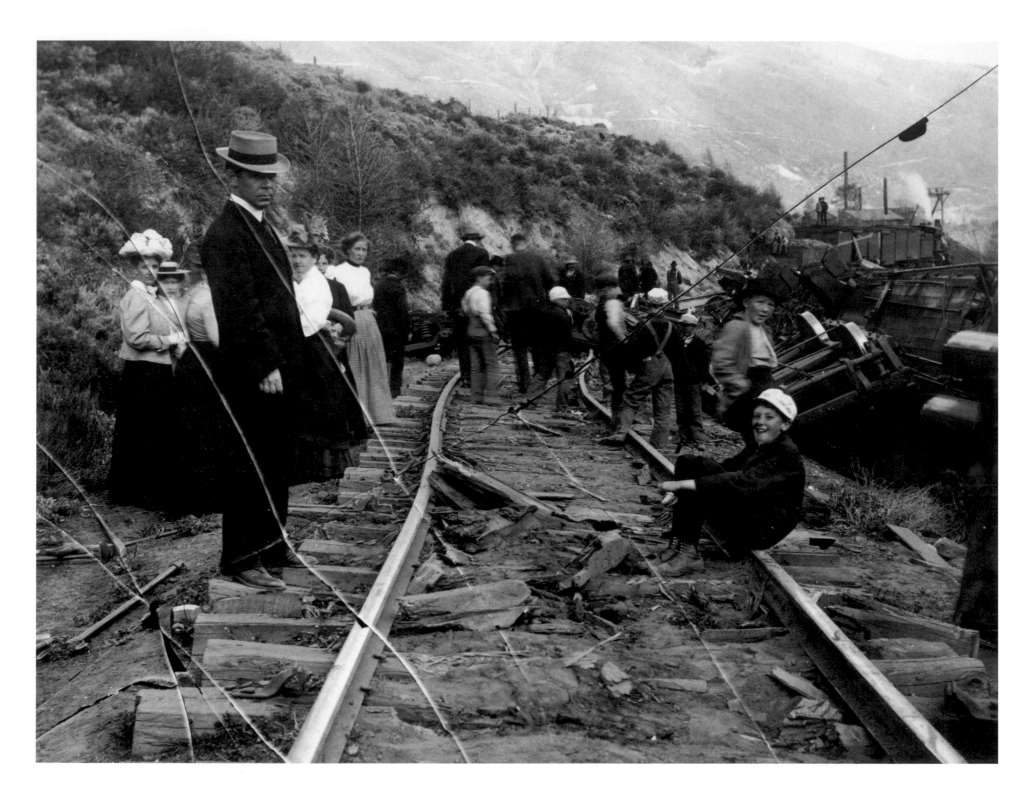

Denver & Rio Grande Railroad accident, c. 1900

Then, without violating the integrity of the image, we can reflect on how his euphoria could have come crashing down with a single instructive word. For childhood is not only about the joy of emotional abandon but the lessons of upbringing—of values, right and wrong, and propriety. These are part of every culture and they are hard-learned lessons.

Is this reading into the photograph something that isn't there? Yes. Is it taking from the photograph something that isn't there? No. Photographs as primary documents, like letters, diaries—and, for that matter, poems—elicit a kind of interaction that is both immediate and intimate. The photograph could be of a 19th-century child or the surface of the moon; in either case, it draws us out. We want to explore the textures and contours of the photograph's particular reality, and we accept the invitation the image offers for speculation. Before 1959 and *Luna 3*, no one could have known the precise configuration of the back side of the moon, but most assuredly it looked like the moon's face.

What the photograph of the laughing boy on the twisted railroad track does *not* tell us is anything about the historical event itself—where the train wreck occurred, who the boy is, how many people were killed or injured, and when it happened. Furthermore, given the ease with which photographs can migrate from one place to another—and be mislabeled—it might not have taken place in Colorado at all. But none of these absent pieces of information has bearing on what we can draw from the image itself—at least for a glimpse of what it was like to be a child in that situation. It would be useless to speculate on those historical facts, for they don't add anything to the picture as we interact with it.

At every turn, when we study photographs as primary documents, we are left to our own judgment and experience—and with a set of decisions to make. We cannot escape reading *something* into an image, either through risk or caution. On the surface, the two nearly identical photographs of this church gathering would make a casual viewer wonder why a second photograph was necessary. Everyone seems to be in place in both images. Perhaps the photographer wanted to ensure that one of them would come out right.

But look at the corner of the church building in the photograph on page 16 (which was actually taken first) and notice the little boy with his head against the wall. The reason for the second photograph becomes immediately apparent.

This, of course, is cheating. Had we only had the second photograph to study, with the little boy relieving himself, the point would have been made explicitly. In this case, however, we would have assumed the photographer had *missed* something—the little boy—as had everyone else. Or we would have assumed that the photographer *knew* what no one else did. Which is the correct approach? As it turns out, the photographer

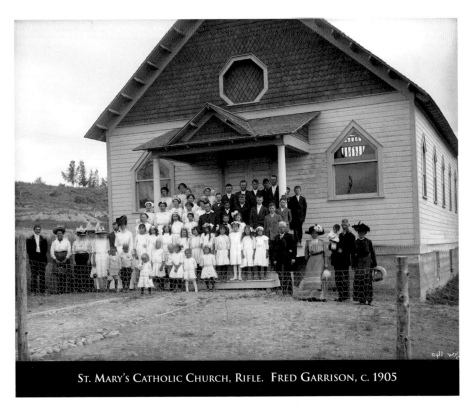

ST. MARY'S CATHOLIC CHURCH, RIFLE. FRED GARRISON, C. 1905

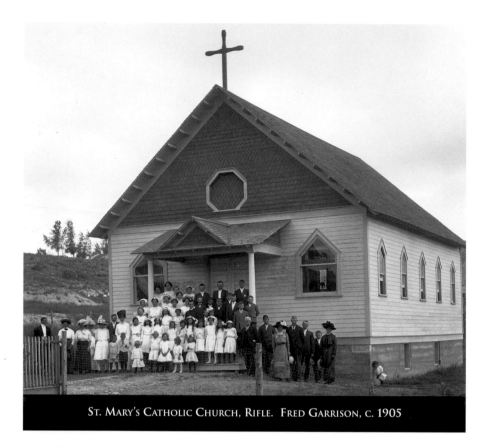

ST. MARY'S CATHOLIC CHURCH, RIFLE. FRED GARRISON, c. 1905

(maybe at the suggestion of someone in the group) made a decent, respectful picture of the congregation, but kept both negatives—fortunately—for posterity.

As tempting as it is to believe that photographs show unvarnished reality, based solely on the information in the image—and absent our own visual skills and judgment—we cannot help but add our own meaning to them. They may be wrong, in the end. They may be correct, in the end. In most cases, we will never know. Interaction with photographs as primary documents is like face-to-face interaction with other people. Is she lying to me? Does he know that what he says makes him a hypocrite? How should I react?

Luckily, historical images of children, like most daily interactions with people, don't provoke an existential crisis. But they do underscore the fact that interpretation is inescapable—that it's fluid and personal. To interpret these photographs of children as nothing but sweet and endearing,

as a historical gallery of soft-focus good feelings about the world, is certainly a choice some viewers might make based on their own needs and experiences. The same holds true of those who might see them as a social record of denial, for children through the ages have been physically and sexually abused, neglected, tormented, and abandoned. But the images themselves don't reflect one viewpoint or another. They are open to interpretation, individually and in the context of their time and setting.

As for this particular collection of images, it does not reflect all aspects of children's lives—which by default represent the reality of childhood—from the 1880s to the First World War. To do so would have meant approaching the subject as a survey, and surveys develop from well-reasoned, informed plans for mapping everything within a territory. They serve to offer information, a sense of orientation, and a guide for others to follow. Most of all, surveys require narratives describing the landscape, its similarities and differences, and the unique conditions of nature and life along the way. But while childhood can certainly be explored and understood within a narrative, the question is, especially with these images, does it need to be?

As a case in point, one subject is not featured among the selected images, though it was—and is—an important component of childhood. Every child knows the reality of sickness and death, and one can argue that for 19th-century children that reality was more pervasive than today. The following vignette attempts to touch that reality.

*You saw sickness often and knew that it could lead to death. So many times you heard someone—perhaps the doctor—say, "The crisis is over." But once, and maybe more often, you heard the worst. For a little while, you were left to yourself, or comforted, or you tried to comfort someone else. Then everyone had to pull together —during the vigil, at the church service, at the cemetery, and home again. Now, for the first time since it happened, you saw that things would never be the same.*

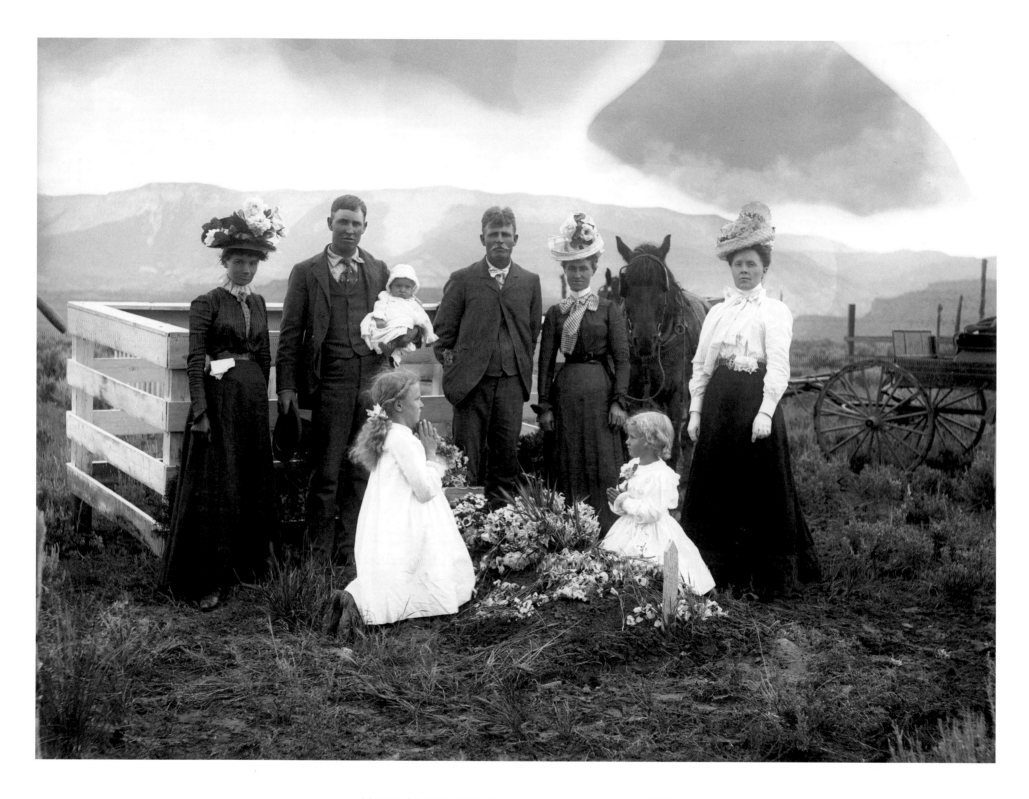

MILLARD WALKER FAMILY, NEAR RIFLE. **FRED GARRISON**, C. 1905

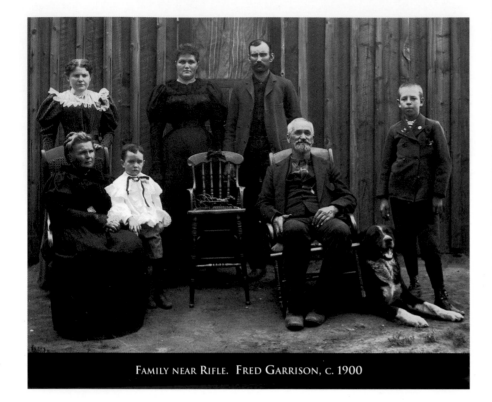

In the image on page 17, striking in its gravity and poignancy, the children praying at the graveside may be in earnest mourning. But, whatever genuine impulses occasioned it, the scene is elaborately staged. So is another recently discovered memorial portrait (above) by the same photographer, Fred Garrison. As the family gathers around an empty high chair, the image graphically depicts the sense of loss and grief, serving as a stark reminder for the other children, as they grew older, of the hole this baby's death made in the family and of the child's continuing place there.

If these images were typical of others in the collection, they might testify to a pattern of ritual moments linked to 19th-century attitudes about the ceremony of death. But few images like these have emerged—and, like the empty high chair, they testify to gaps in our representation of 19th- and early 20th-century childhood that can't be filled by photographs alone. In spite of the sleight-of-hand that saves the vignette on page 16 from oblivion, there is little in the Colorado Historical Society's collection

of photographs that testifies to this experience as children might have encountered or expressed it. Colorado's professional photographers did not follow families to graveyards unless invited—nor did they interrupt church services, capture domestic disputes that spilled out onto the street, or document injured patients in hospital admissions wards.

In short, the known and unknown photographers who contributed to the vast body of images in the Society's collection represent attitudes and values that prevailed for decades up to and beyond World War I. They did not ignore the rural poor, people of color, working children, American Indians, or other ethnic groups. But their interests, outside of making a living, followed personal idiosyncrasies and largely unexplained predilections. So far as we know, Colorado produced no socially minded photographers like the reformer Lewis Hine or the WPA photographers of the 1930s. The state did, however, make a home for everyday photographers such as Charles Lillybridge, who produced a remarkably broad and egalitarian record of daily life along the streets, paths, and alleyways of Denver; O. E. Aultman, who took up a career as a portraitist in Trinidad and brought flashes of eccentricity to his work; and Fred and Ola Garrison, who combined portraiture and everyday scenes in a body of work filled with human sympathy and intelligence.

Fewer than half of the known photographers represented here, however, were professionals. Most of those who can be identified were family members making photographs of their children and their children's friends. The images they produced—and many could not be included because they are out of focus—are as far from the harsher social realities as the ample homes in Denver's Capitol Hill area were from the cribs and opium dens along Market Street. Children lived in both worlds, just as they lived in the Trinidad-area coal camps, the sugar-beet towns in northern Colorado and along the Arkansas River, and in the experimental social communities such as early Greeley (Union Colony), the Jewish community at Cotopaxi, and the Salvation Army's colony, Fort Amity.

BELLE BIRNARD'S PARLOR HOUSE, DENVER, C. 1885

Two images, which pose a more sobering view of children in early Colorado, should disabuse anyone of the notion that childhood—then or now—is idyllic. The girl in this often-reproduced photograph of prostitution in Denver's red-light district is barely more than a child. The boys in Judge Benjamin Lindsey's courtroom—the first juvenile court in the nation—have been equally hardened to life on the streets, presumably without the comforts of home, family, or caring parents (page 21).

To focus on abused and neglected children, or children who spent a good portion of their youth working in mines or laboring on farms, would be to emphasize particular conditions over the common aspects of childhood that most of these photographs convey. We care about the children in these images because we can relate to them—even though they may not be our parents and grandparents—and because we share certain memories of childhood that make such empathy possible. The personal conditions of our early lives, including differences of sex, race, ethnic background, health, social status, opportunity, inner characteristics, and good or bad fortune all operate within—or against—a fundamental backdrop of family, friends, home, work and play, and the larger world of village, town, or city.

These images, we hope, will link these differences to the similarities of childhood experience across time, people, and place. In doing so, however, we recognize the limitations of context that any photograph, or assembled collection of photographs, can offer without a knowledge of the circumstances in which it was made. One of these is expressed in a photograph of a girl mopping her parents' kitchen floor (page 20). Few of the photographs we found depicted children doing chores, and this one is doubly unusual because the angle of perspective is so low, not one that would be expected of an adult. This is because Anna Kennicott's photographer was her elder sister, Eugenia, whose father introduced her to photography because she was stricken with a debilitating illness at the age of two and couldn't enjoy other activities.

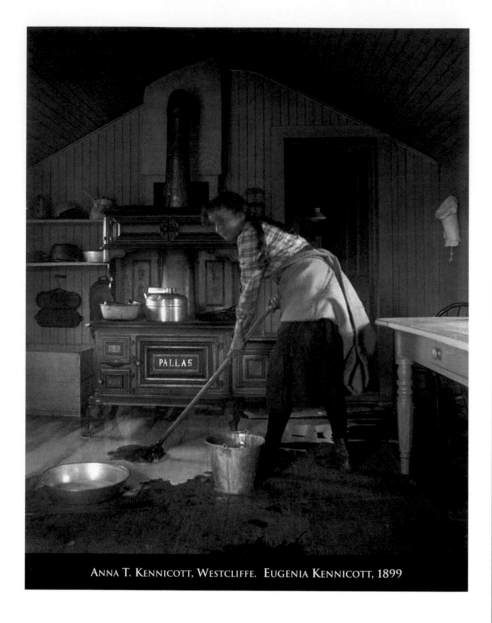

ANNA T. KENNICOTT, WESTCLIFFE.  EUGENIA KENNICOTT, 1899

Nevertheless, the half-truth expressed in the beginning of this introduction, that childhood is a personal possession, also implies the other half—that in some of its most basic features, childhood is universal. Then, as now, some children had no families to speak of; some never went to school; and some did not have friends. But, as the images in the collection express over and over again, the themes of family, play, friends, school, and the dynamic of indoor-outdoor life touch upon childhood's main currents.

As suggested in Eugene Field's poem *The Brook*, we can be mesmerized by currents of time as we look at these images—observing unknown children from a distance, reflecting on our own past, and realizing that childhood is *always* seen through the past. "There were rushes and willows in that place," Field writes, "and they clutched at the brook as the brook ran by." In the same way, the vignettes accompanying these images try to touch, here and there, that common surface.

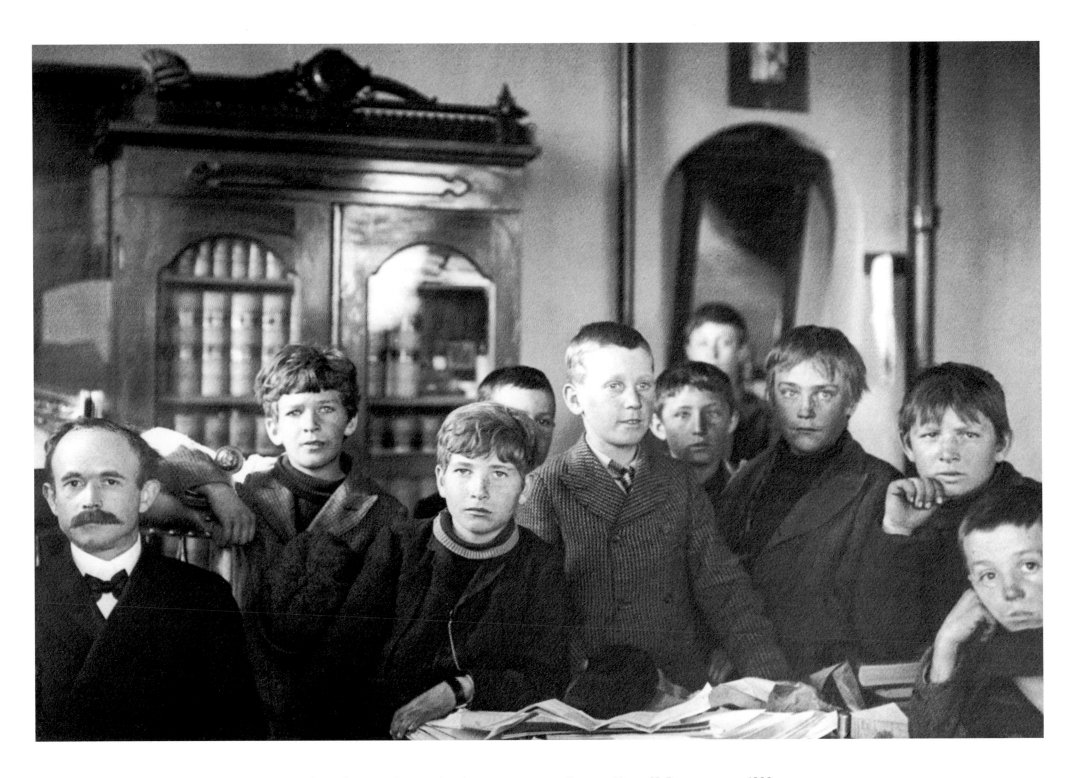

JUDGE BENJAMIN LINDSEY *(LEFT)* IN JUVENILE COURT, DENVER. HARRY H. BUCKWALTER, C. 1908

 # FAMILY

Being part of your own family was such a natural thing that you hardly ever gave it a second thought. Every day you awoke to the sound of your mother's or father's voice and before you went out you saw or spoke to each one of your sisters and brothers. Only once in a great while did you really think about what it meant to have a family, and that was when something in it changed—the birth of a new baby, moving to a different house, or when an older brother or sister left home. Soon, however, things seemed to return to the way they were before, and you could forget once more that you had a family at all.

But there were also times when you saw your family as part of a much larger family of grandparents, aunts, uncles, cousins, and other relatives. On certain weekends and holidays, or at reunions, it was something of an adventure to see everyone together again, just as you remembered them. No one—least of all the older folks—ever seemed to change. It was only when you listened to them speak to each other, mother to daughter and brother to sister, that suddenly you realized who your grandma and grandpa, or aunt and uncle, really were. And somehow the thought that your parents still belonged to their own families made you hold on to yours even more.

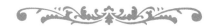

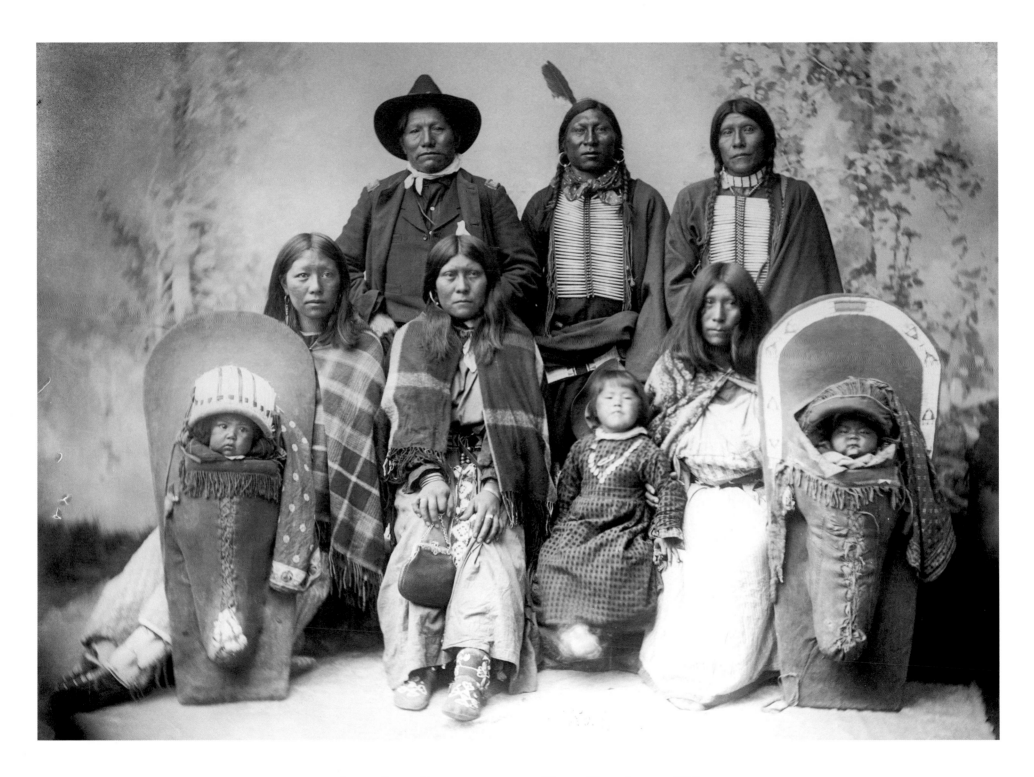

SEVERO, CAPOTE UTE CHIEF, AND FAMILY. WILLIAM HENRY JACKSON, 1889

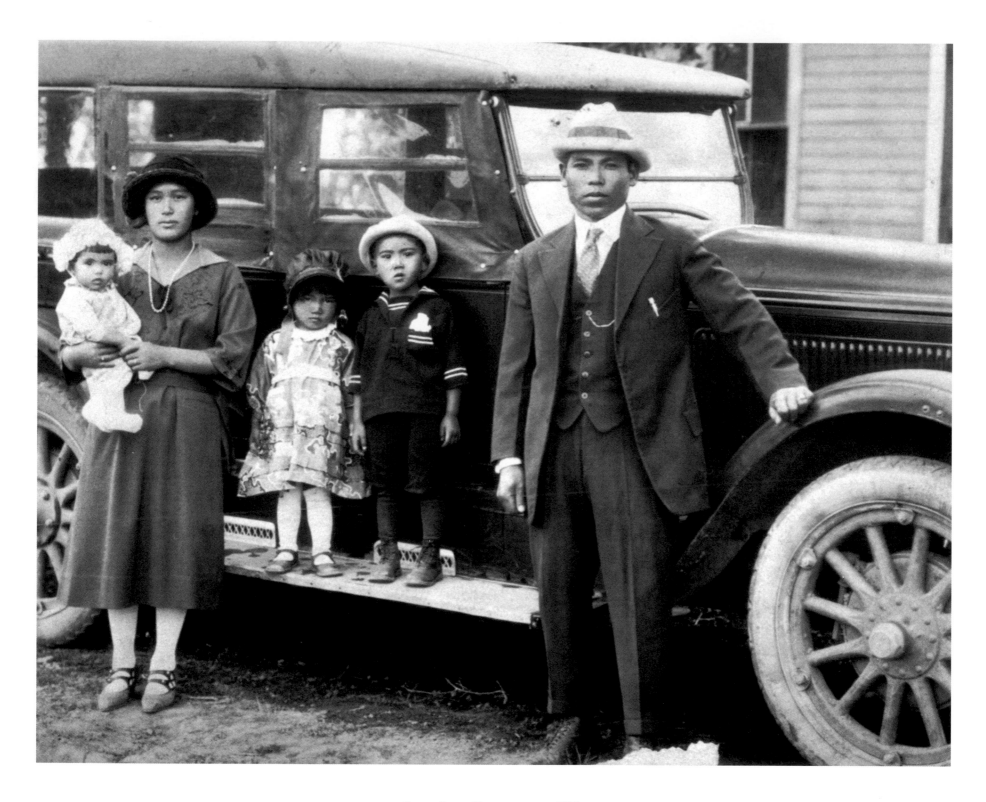

Frank Eiichi Yoshida family, 1925

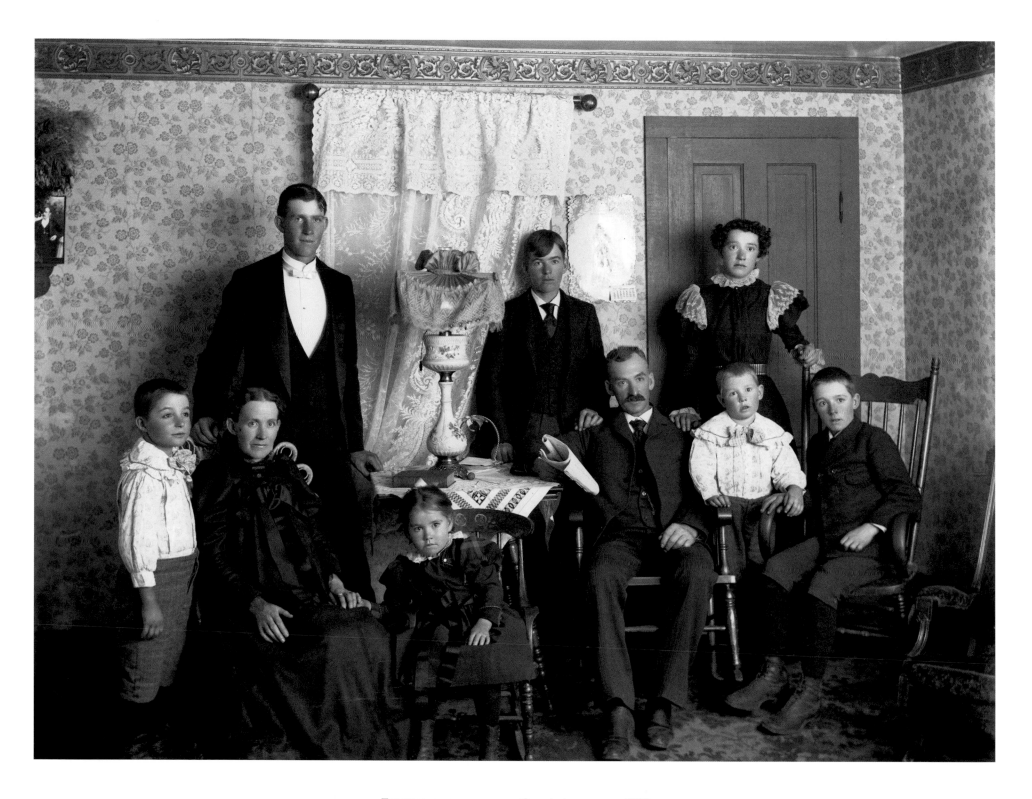

Trinidad family portrait. Otis A. Aultman, c. 1895

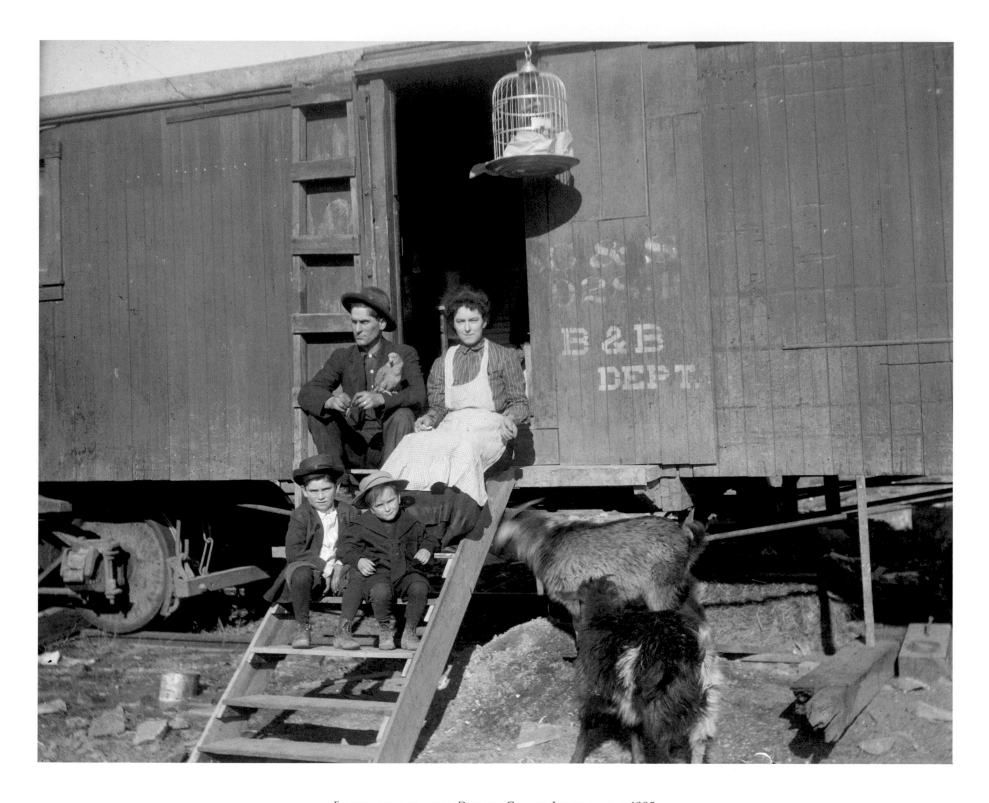

Family in boxcar home, Denver. **Charles Lillybridge**, c. 1905

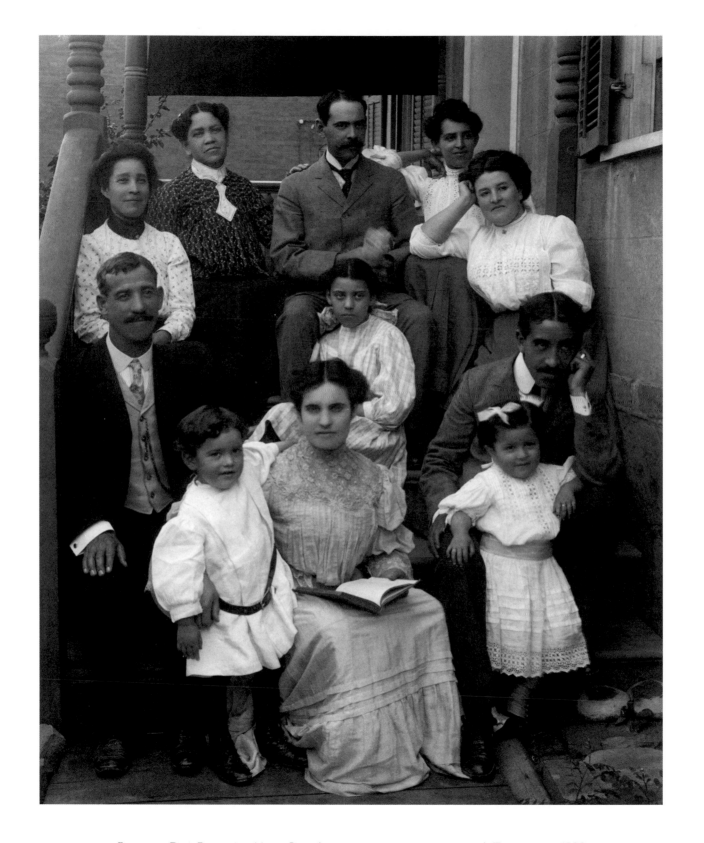

Family of Don Felipe and Maria Baca (second and third generations), Trinidad, c. 1900

# PARENTS

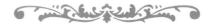

Your parents were where you came from—and, for good or ill, you belonged to them. It was not simply that they could protect you and punish you; by their very presence they could make your life a heaven or hell. In their presence, in fact, you were always conscious of what would please them and what would not. And in a thousand small ways you noticed how they noticed you. Did your mother come to you when you hurt yourself? Did your father tell you to behave more like a sister or brother? Did your mother stand up for you when your father was angry? Did they talk to you, and did they listen? All these things and more told you what they expected of you or thought of you—and, almost instantly, how you thought of yourself.

You belonged to them so much that, at times, you struggled against it. You sometimes thought about running away and never coming back. Or, you thought how much you hated them and wanted them punished. Or, you did exactly the opposite of what they wanted. But, in the end, there was no one else— not an aunt, uncle, teacher, or friend—you could belong to and nowhere else to go. And when you came back, from tears or anger or loneliness, nothing could compare to the momentary feeling that the world (and everything in it) was all right again because you were in a parent's arms.

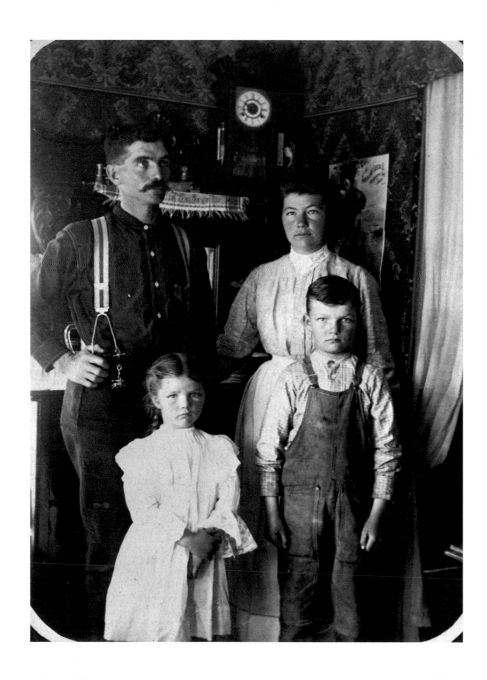

ROSS J. WESTON, WIFE ELIZABETH, AND CHILDREN EARL AND JUANITA, GRANBY, C. 1905

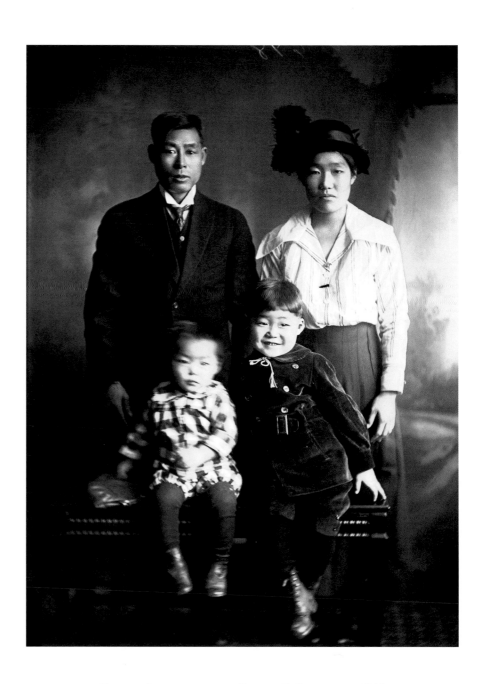

CHINESE AMERICAN FAMILY. **EVERETT R. JOHNSON**, C. 1915

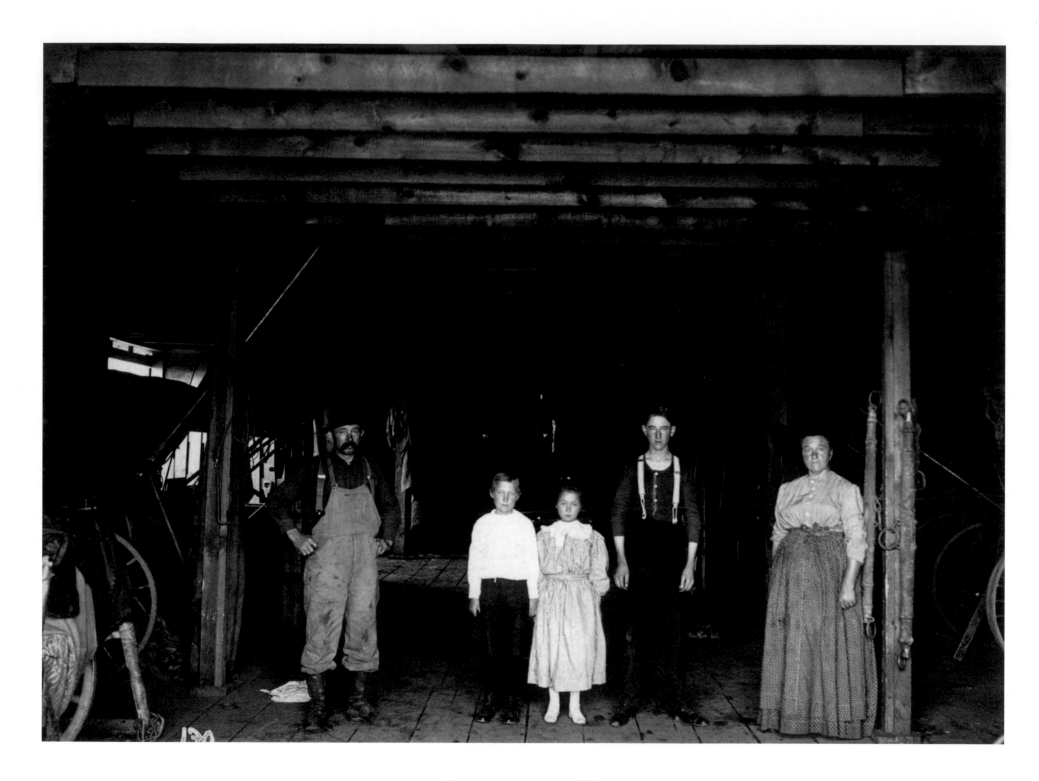

Trinidad area family, c. 1905

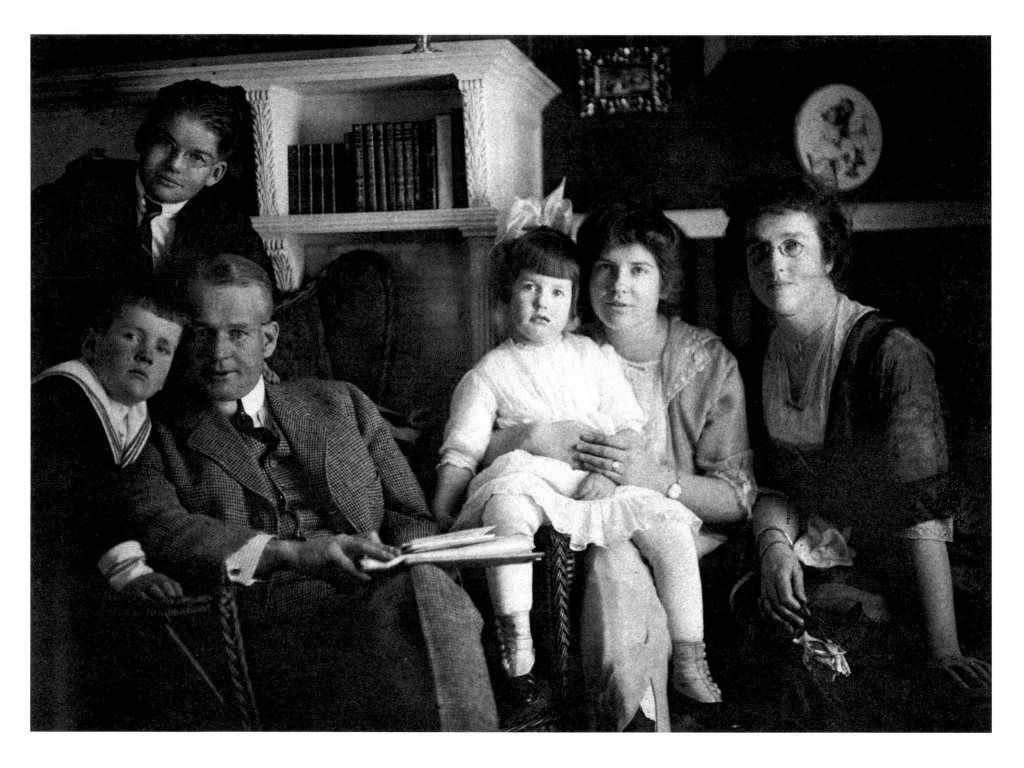

HAROLD W. MOORE FAMILY, 1410 HIGH STREET, DENVER, C. 1915. *GROUPING AT LEFT, CLOCKWISE FROM TOP:* JOHN, HAROLD MOORE, TOM.

*GROUPING AT RIGHT, LEFT TO RIGHT:* MARY LOUISE, RUTH, AND MARY (MRS. HAROLD) MOORE.

 # MOTHER

Y ou knew your mother's face better than you knew your own. No matter how plain or pretty, young or old, kind or cross, her face beheld a knowledge you never stopped seeking. You could see your inner self in her face as if it were a mirror—who you were to her, and she to you—for just as long as you cared to look. You could turn away from anyone else sooner than your mother, for to deny her look was to deny the privileged place you had with her. She could make you feel naked and ashamed, bathed in forgiveness, or corrected with a glance. Her very expression could hold you up and tell you she believed you, or believed in you, from the time you could walk. And, as she taught you—to read, to cook, to play the piano, to hang up your clothes—her hands and voice might show you how it's done but her face told you how well you had done it.

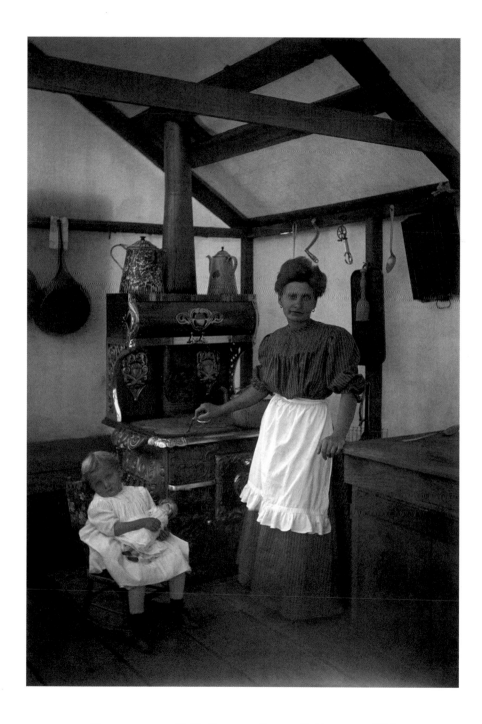

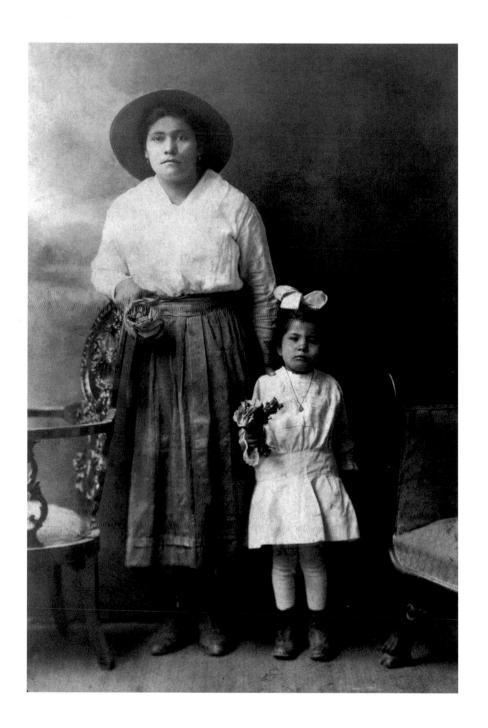

Kitchen scene. **C. H. Clark or George E. Mellen**, c. 1905

Francisca Contreras and godchild Maria Vilegas Ruiz, Pueblo, 1917

33

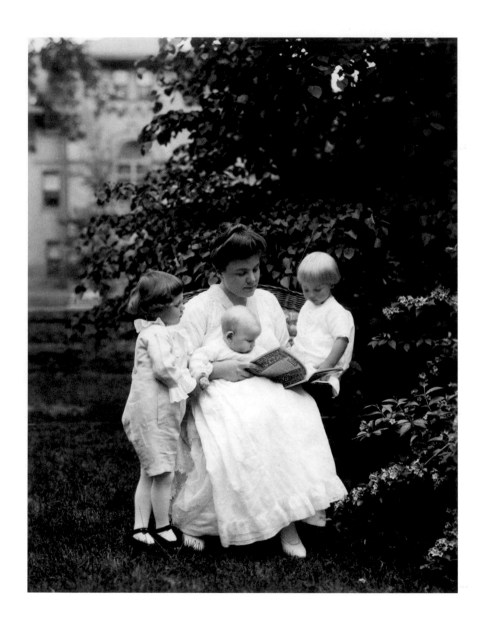

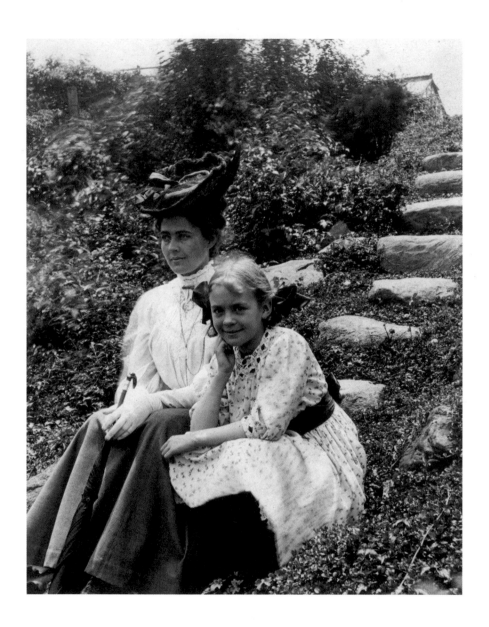

ZEPH CHARLES FELT FAMILY, C. 1910

*ON REVERSE SIDE OF PRINT:* AMY AND DOROTHY, SOUTH PARK, HORTICULTURAL

GARDENS. "WHEN THE BLOOM WAS ON THE CLOVER,/AND THE BLUE WAS IN THE SKY."

WINTER FAMILY COLLECTION, JULY 1906

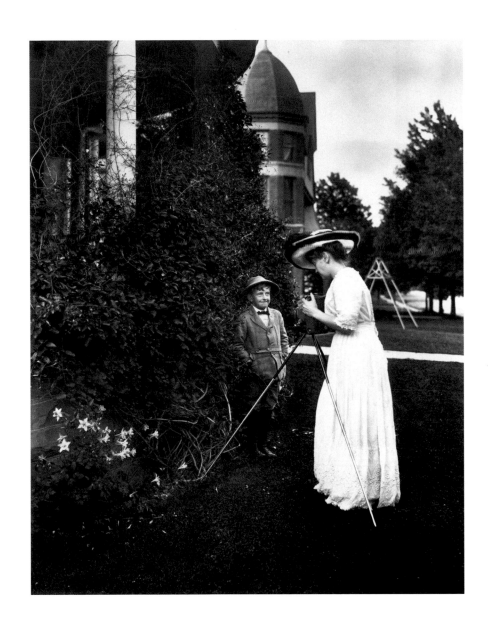

GLENN AULTMAN AND HIS MOTHER IN TRINIDAD. **OLIVER E. AULTMAN**, C. 1910

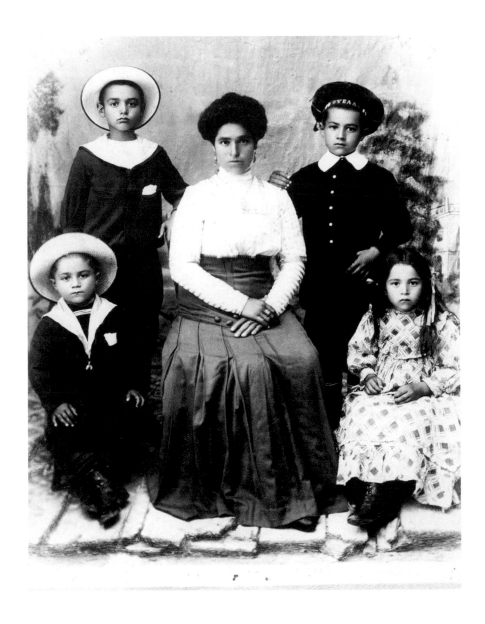

TRINIDAD AREA FAMILY, 1890S

# FATHER

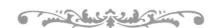

*Even when your father wasn't there, he was present. He could be near you, helping you with your school lessons, listening while you told him about your day, napping as you walked ever-so-quietly about the house. But when he was gone—off to work, out with friends, or whatever—his image could linger in your head. And usually it was the last glance you had of him before he left, whether he was preoccupied or busy, laughing and joking, serious or concerned, that stayed with you throughout the day. Even if you didn't always keep him in mind when he was gone, you could immediately recall the parting sound of his voice. It could be comforting and kind, and bring you close to him; or distant and occupied with other things; bright and cheerful; or, in some cases, loud or angry enough to drive you into your mother's arms. In any case, when he returned, you listened to the tenor of his voice as much as the expression on his face—for it told you whether things would be all right or not.*

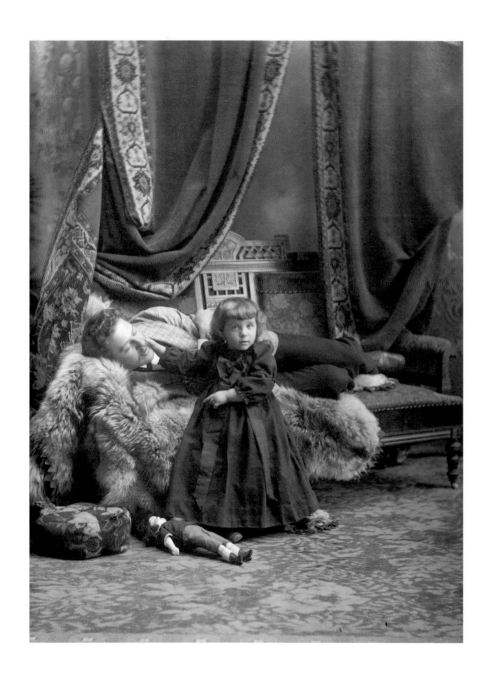

STUDIO PORTRAIT (JULIUS MANSBACH FAMILY). **OLIVER E. AULTMAN**, 1892

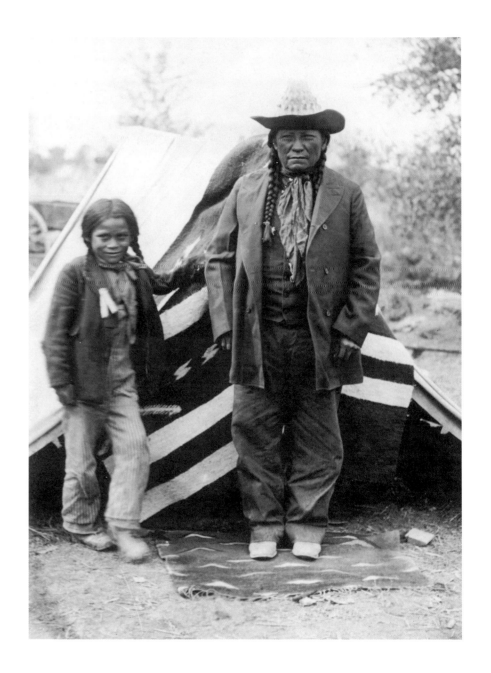

UTE CHIEF McCOOK AND BOY NAMED APUTS, C. 1905

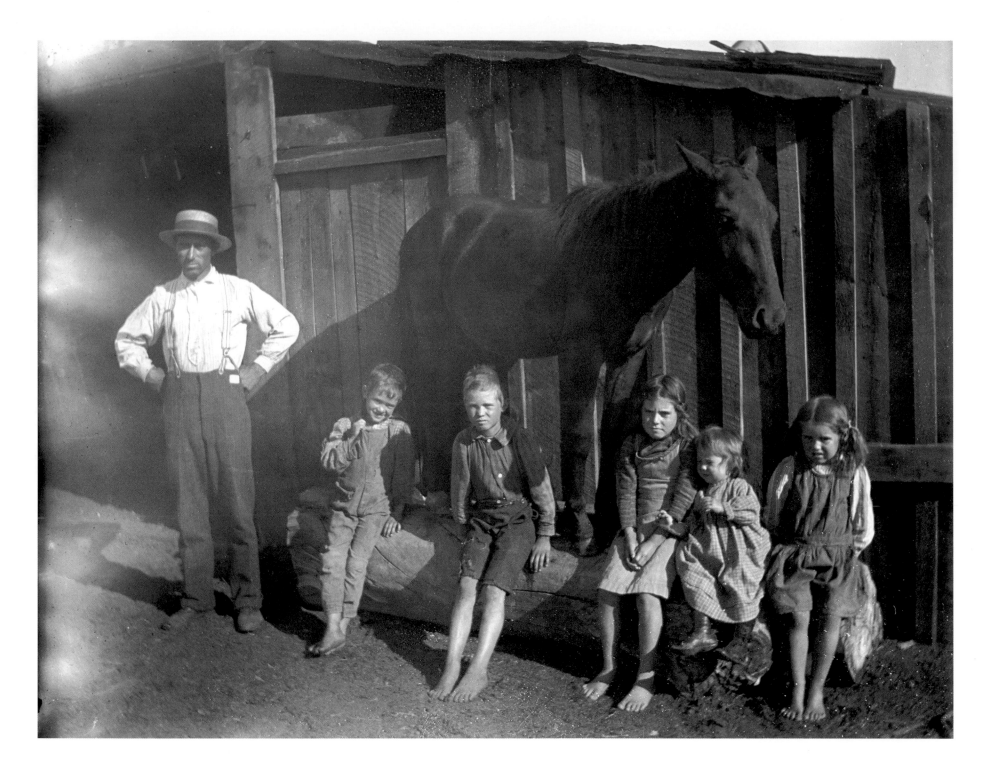

CHILDREN ON LOG WITH HORSE, DENVER.  CHARLES LILLYBRIDGE, 1904

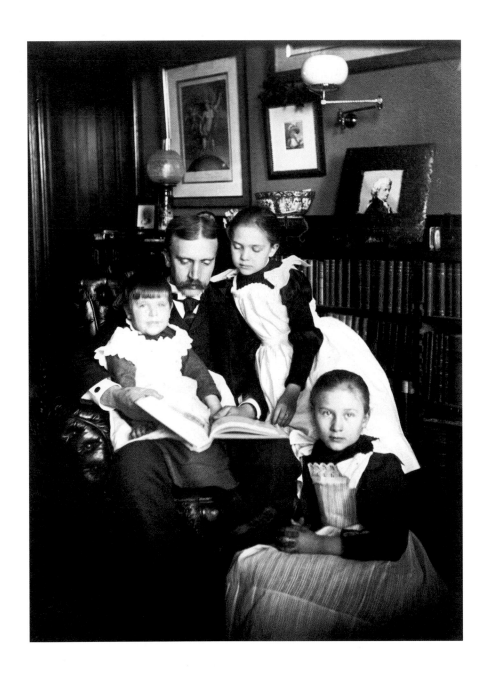

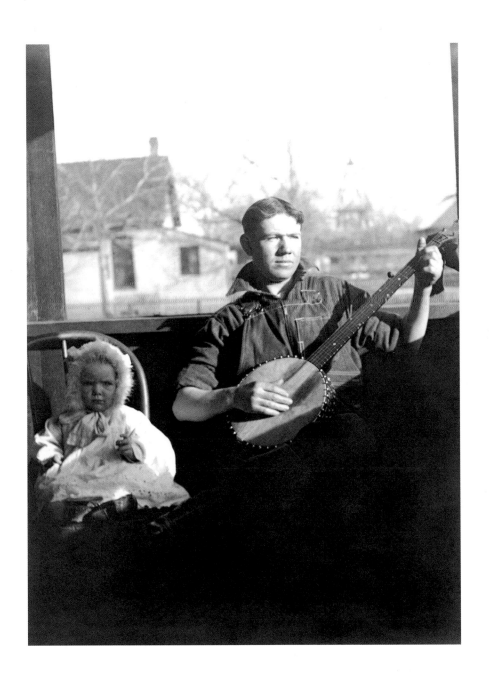

JOHN L. JEROME WITH DAUGHTERS ELIZABETH *(ON CHAIR ARM)*; CORNELIA *(ON FLOOR)*; AND JANET *(IN FATHER'S LAP)*, DENVER, 1888

MAN PLAYING BANJO, WITH INFANT, IN DENVER. **CHARLES LILLYBRIDGE**, C. 1904

#  BROTHERS & SISTERS

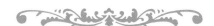

*E*ven more than your home, your family gave you a sense of place. You might be the oldest or the youngest, or one in a family so large it took outsiders some time to get the names straight. But you knew who was above and below you, whose clothes you would get, and whose chores you would take over. Whether you fought against it or not, your place was secure. This was true even when a brother or sister died; they were no longer there, but their places remained.

In any case, two rules of the family came first: obey your parents and get along with one another. There was no spoken law that said you also had to love each other, but how could you not? You might even have had a favorite, an older brother or sister you dearly loved and looked up to, or a younger one you teased without fail.

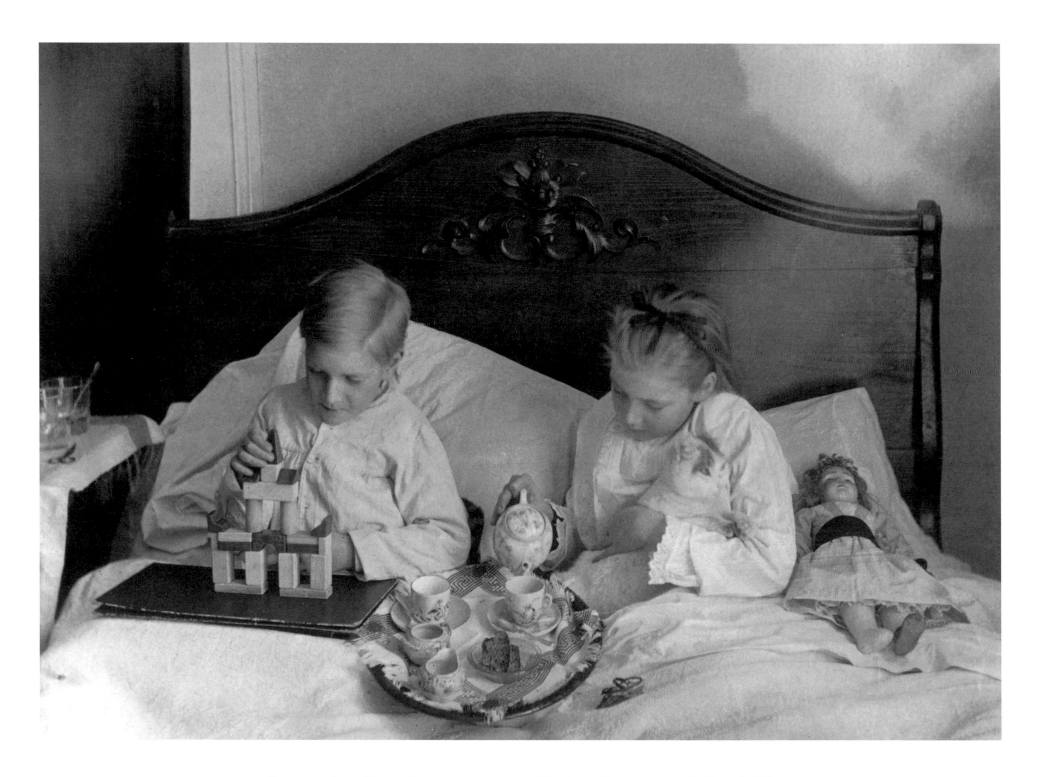

ROBERT AND IRENE HOOD. *On reverse side of print:* "THE LITTLE CONVALESCENTS—LA GRIPPE." 1892

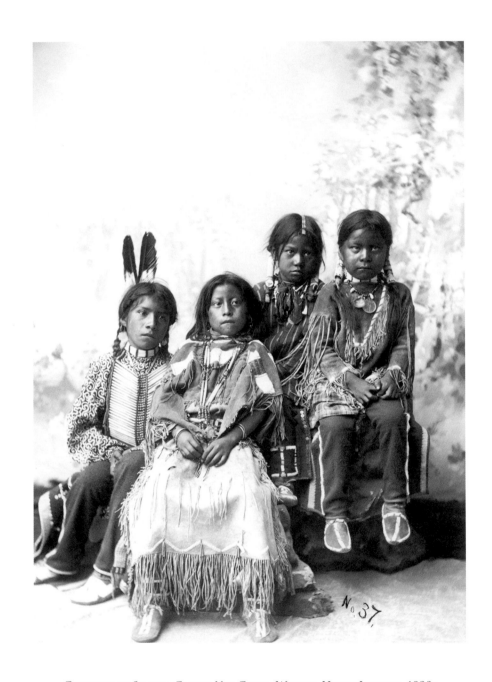

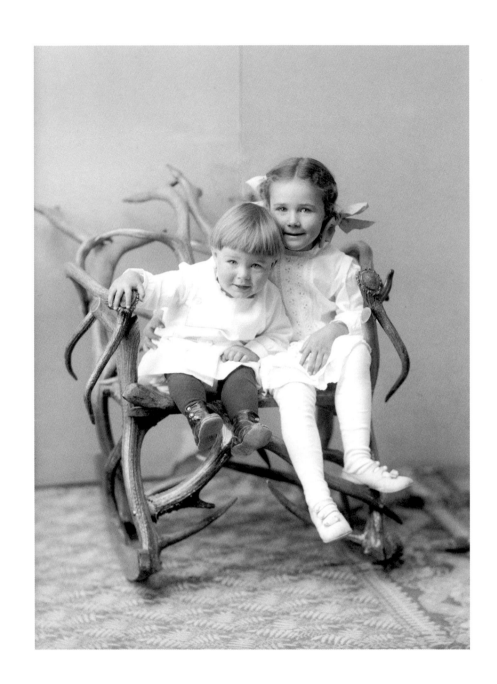

Children of Severo, Capote Ute Chief. **William Henry Jackson**, 1890s

Rifle girl and boy in elk horn chair. **Ola Garrison**, 1910

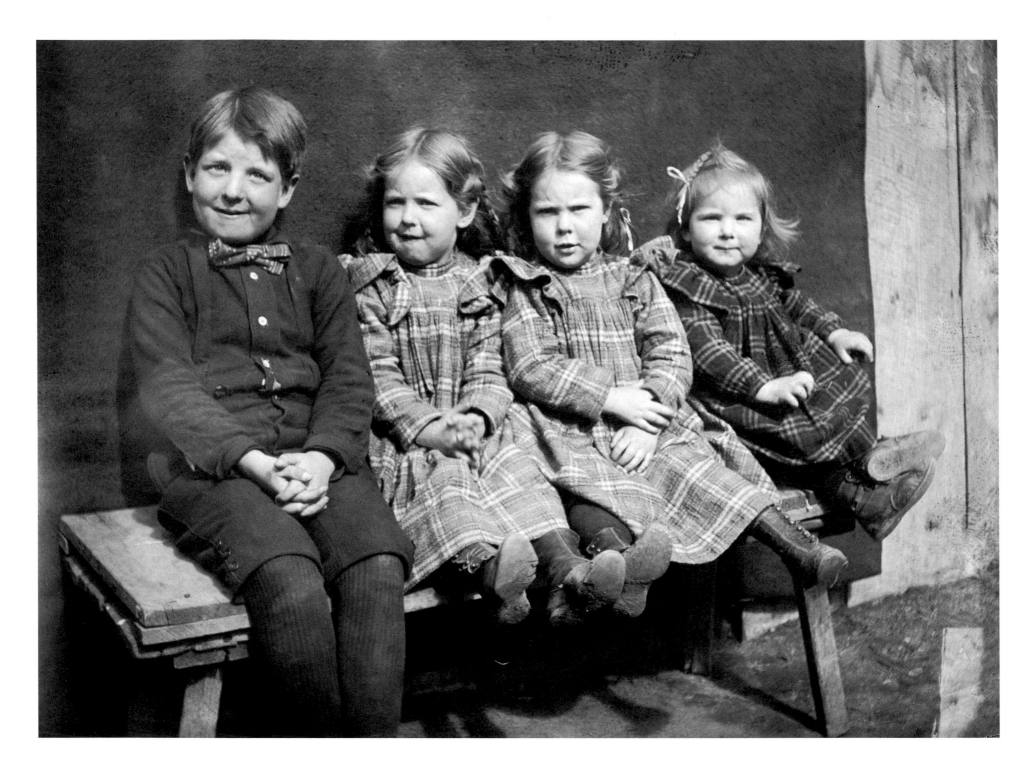

ROBERT, OLIVE, RUTH, AND EUNICE BARKER, C. 1900

# GRANDMOTHER

Y*ou might be fooled into thinking that your grandmother was there only to give you treats, listen to your stories, and come up with remedies when you were sick. If so, you would soon discover—with a shock—that she also felt free to correct your bad habits and to tell you bluntly what she thought of your behavior. In some ways, and so different from your grandfather, she seemed to look right into your very soul. You could come to her with almost any problem and there was hardly anything she wouldn't give you, yet she only accepted your love along with a healthy sense of respect.*

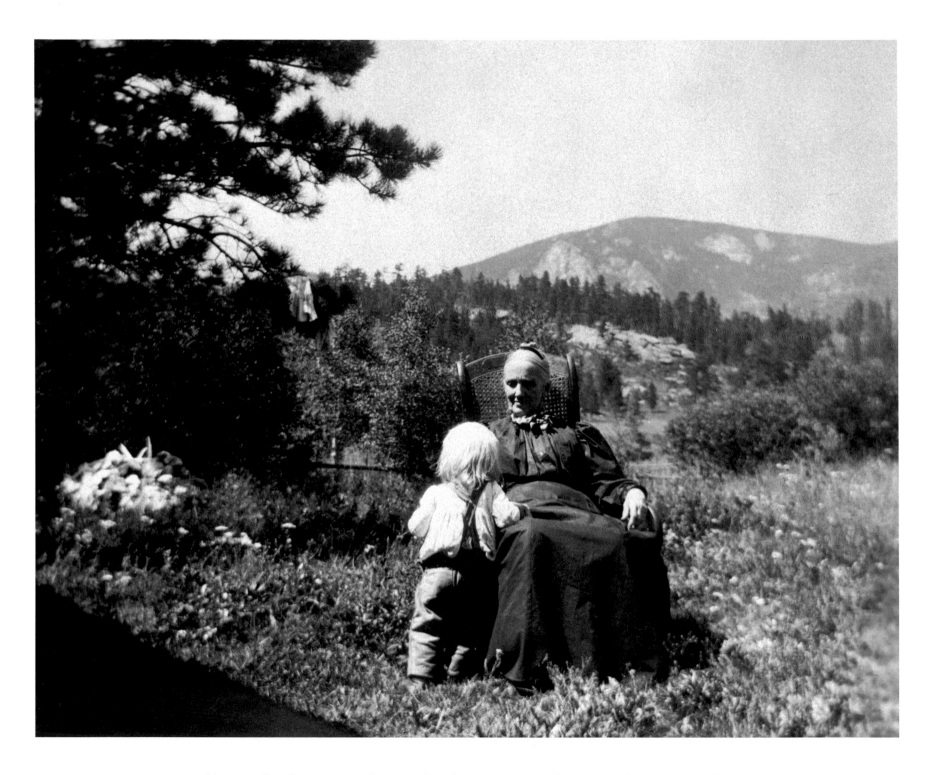

MARGARET GRAY EVANS, FORMER COLORADO FIRST LADY, AND CHILD AT EVANS RANCH, EVERGREEN , c. 1900

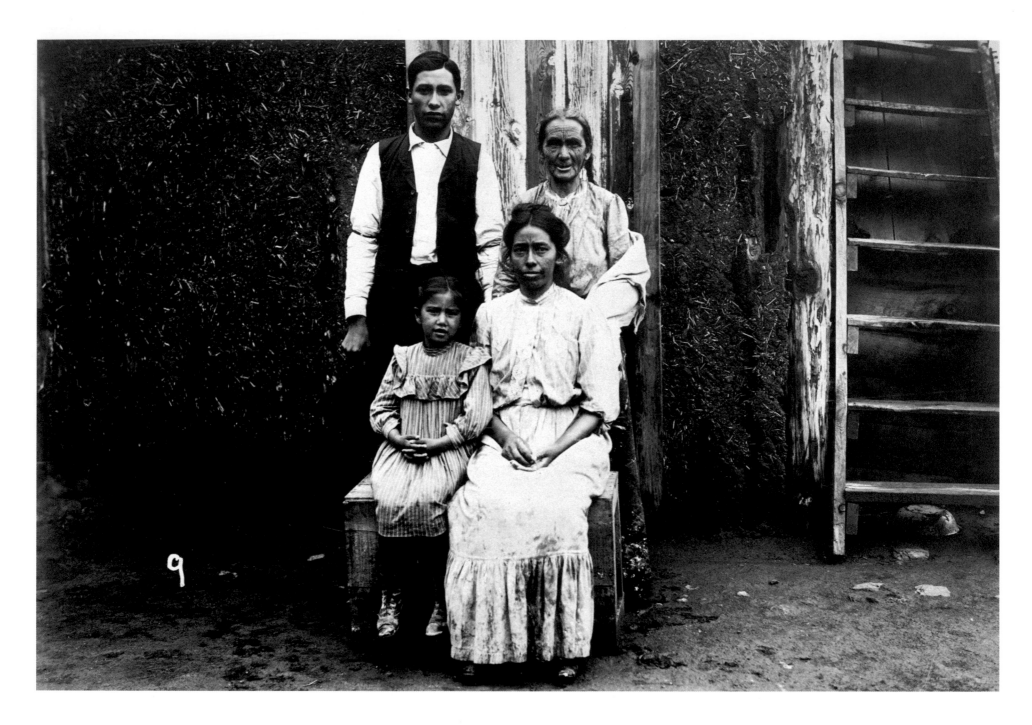

Trinidad area family, c. 1900

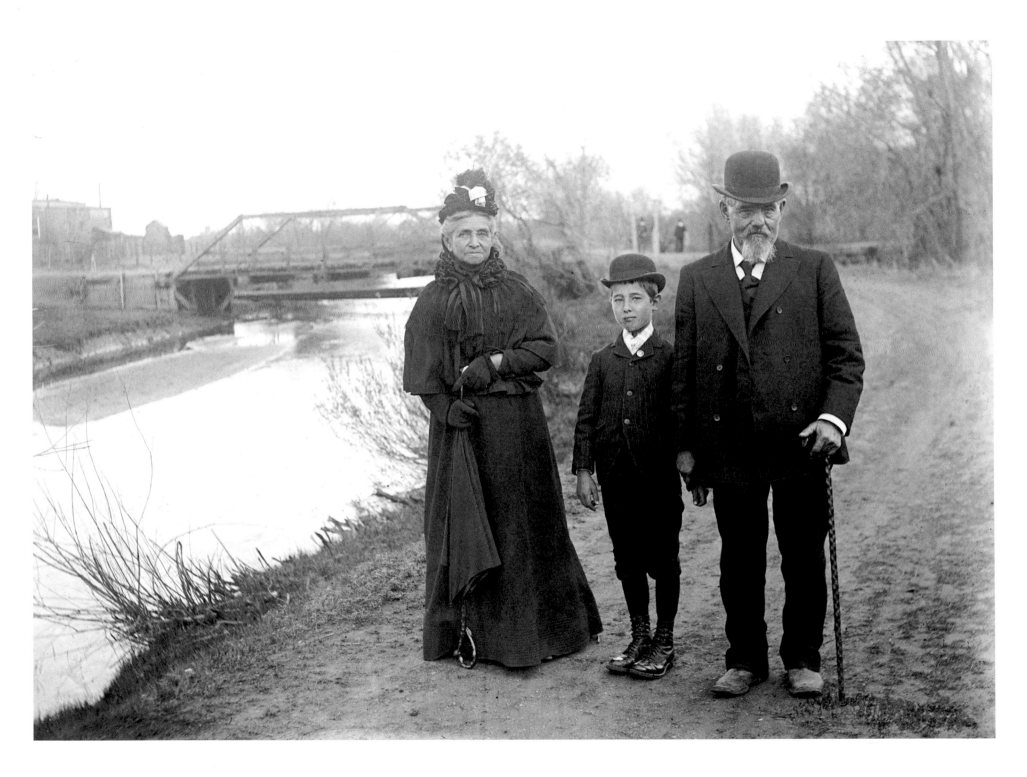

On the South Platte River, Denver. **Charles Lillybridge**, c. 1910

 # GRANDFATHER

Your grandfather was a man you could study for hours. When you were very young, there was at least one thing about him that fascinated you—something in his face or hands, a watch he may have carried on a chain, or the aroma of tobacco that permeated the fibers of his suit. Later, you might have become familiar with other things: he served in the Great War, he was born in the Old Country, he was the first in the family to come West. But these and other mysteries about your grandfather never became as sharp and clear as the power of his presence, one that you could sense in the cut of his beard, the size of his boots, or the glint of his steel-framed glasses.

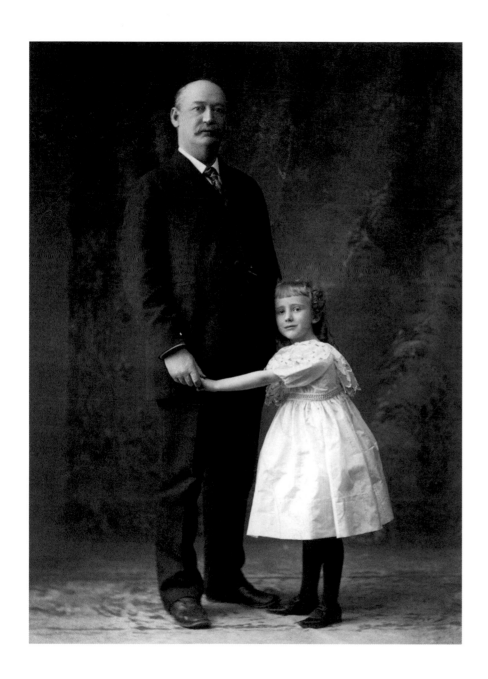

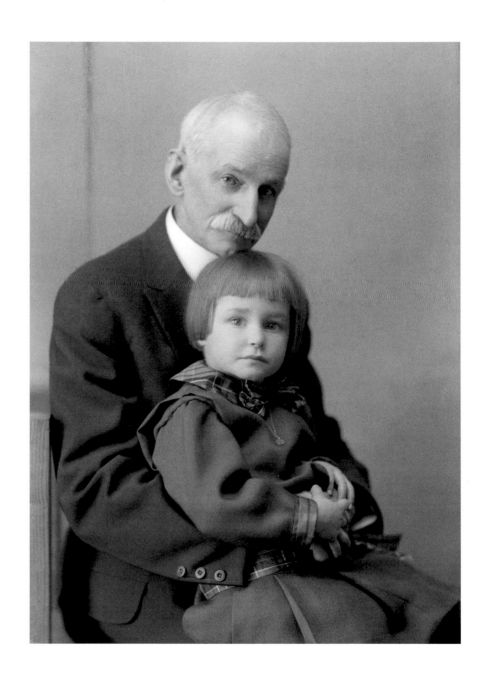

David Moffat with his granddaughter, Frances McClurg, Denver, c. 1900

Rifle grandfather and grandson. Ola Garrison, c. 1910

49

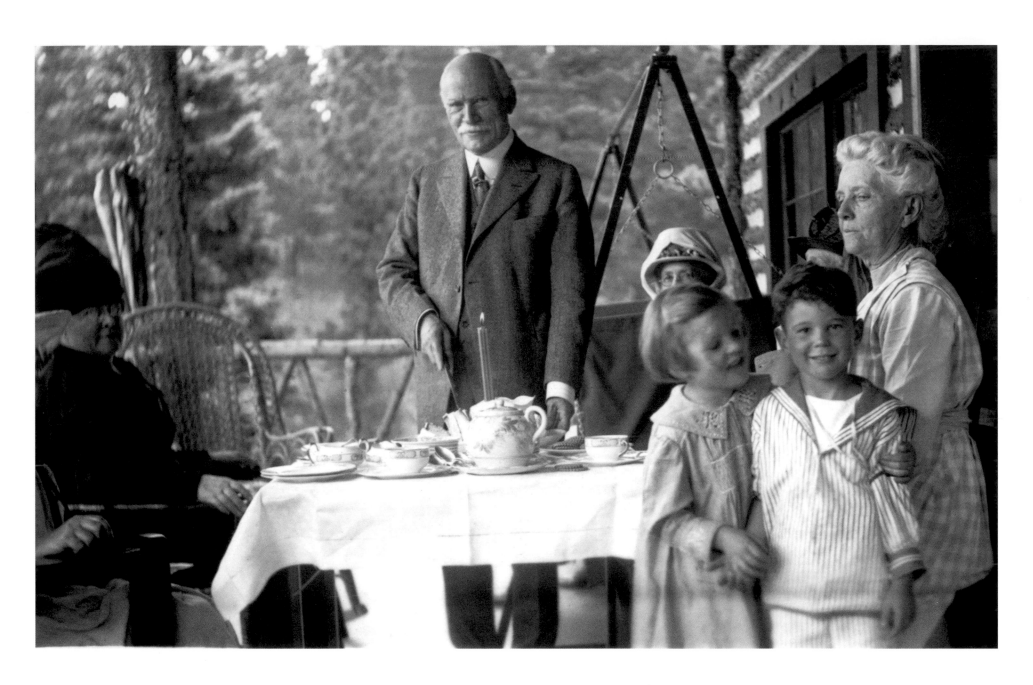

Mr. and Mrs. Owen E. LeFevre at granddaughter Frederica Eva Bellamy's birthday party, 1920

Denver backyard portrait. **Charles Lillybridge**, c. 1905

# OUTDOORS

Y*ou came to know your own house as instinctively as you knew your own body and mind. The creak of the floorboards as you walked into the kitchen—or any other little thing that you heard, felt, or saw within your home's walls—became a part of you. Over time, slowly but surely, you explored the house and its rooms, corners, closets, windowsills, walls, stairwells, furniture, stove, curtains, and cabinets. You knew where your mother put the soap dish, and the smell of the soap, and the color of the porcelain or stain of the wood underneath it.*

*Outside, however, it was different. Once you stepped across the threshold, you immediately saw the sky, the horizon, and the landscape before it. As in your house, you grew familiar with the setting—trees, houses, gardens, fences, roads, fields, hills, and the whole shape of the earth around you. You could find your way down the block, or around several, and walk to the store or to school. Or, you could go beyond the cow pasture to a rock-filled creek and follow it for a mile or two. But, however far you traveled, alone or with friends, there was a tether inside that always tugged—and that was time. From having made some bad mistakes, you quickly learned that the measure of time outside was how long it took you to get back home before dark.*

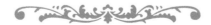

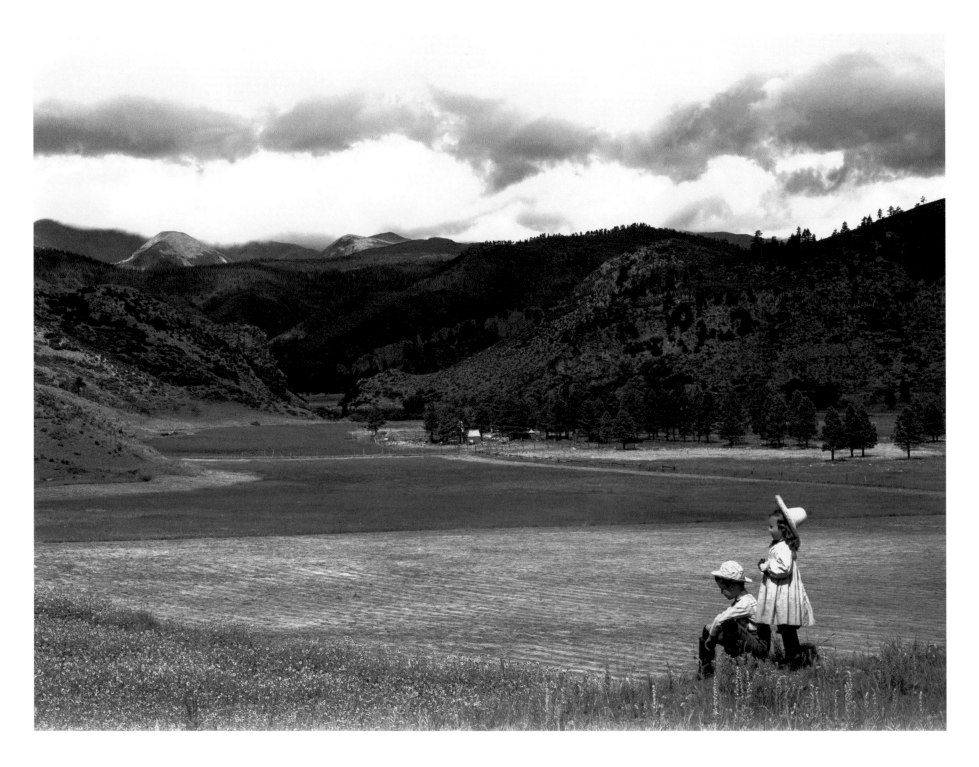

Overlooking southern Colorado valley. **Theodore A. Schomburg**, c. 1905

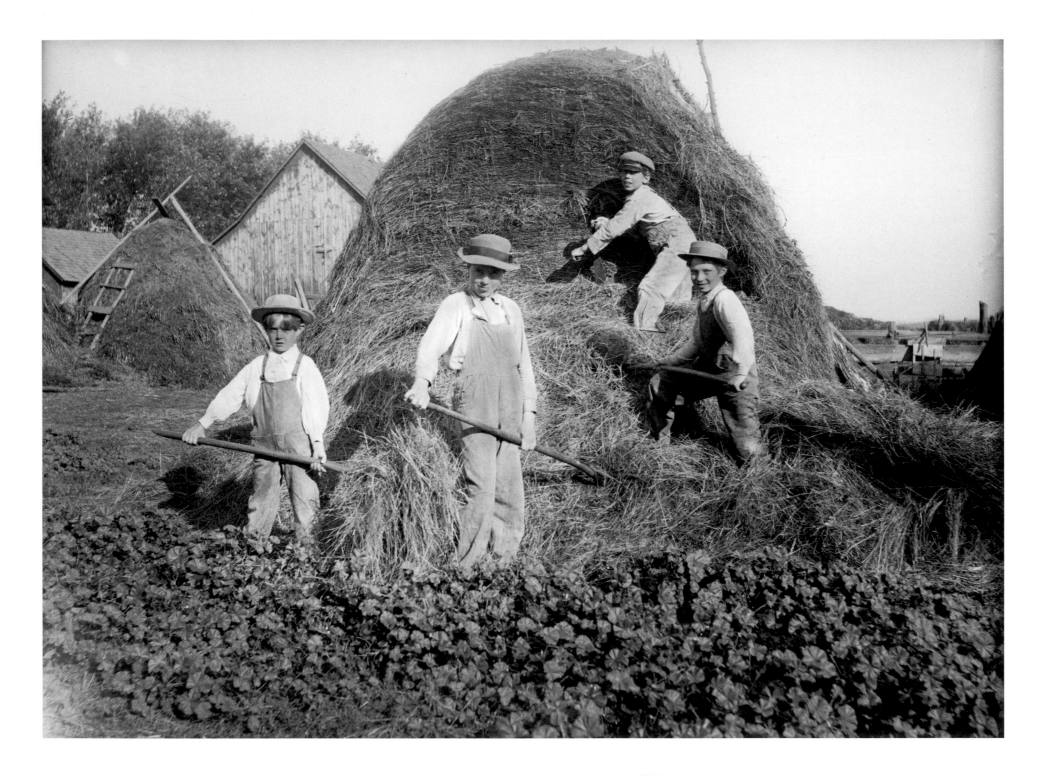

Farm work on Western Slope. Ola Garrison, c. 1910

CAMPING OUT. THEODORE A. SCHOMBURG, C. 1915

 # YARD

When you went into your yard, it was like walking out into a home of your own. It didn't matter whether the yard was green and well kept or nothing but a dirt patch—or whether it extended to a road, a newly laid sidewalk, or a line of poplars standing in the headwind. If you were lucky enough to have a swing, a playhouse, or a tree house, your yard might become a center for all the other children, but you would be just as happy to play in someone else's yard. For there was more to a yard than what it offered in the way of good climbing trees or swings or playhouses. It was a haven, a place where you could simply sit down and do nothing at all.

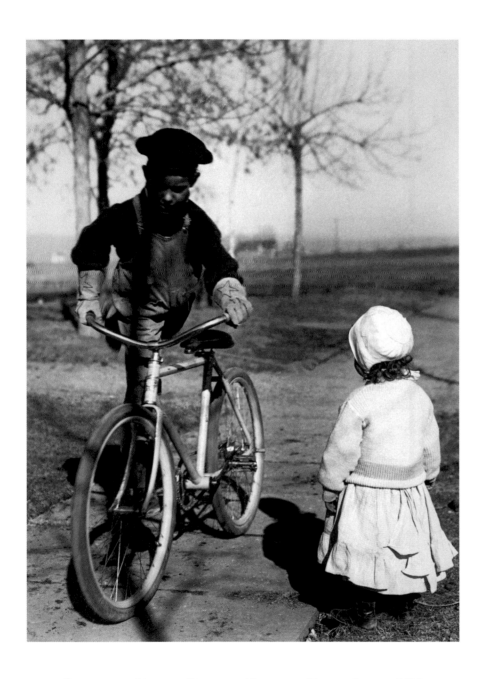

RICHARD AND VIRGINIA DOWNING, MONTCLAIR, DENVER, JANUARY 1906

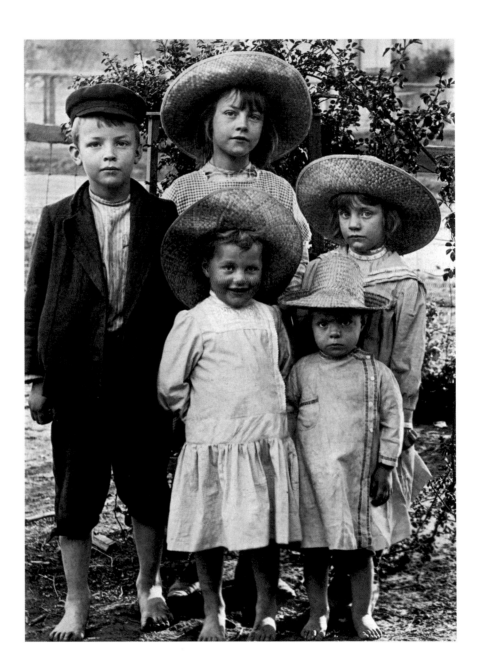

CHILDREN IN YARD, C. 1900

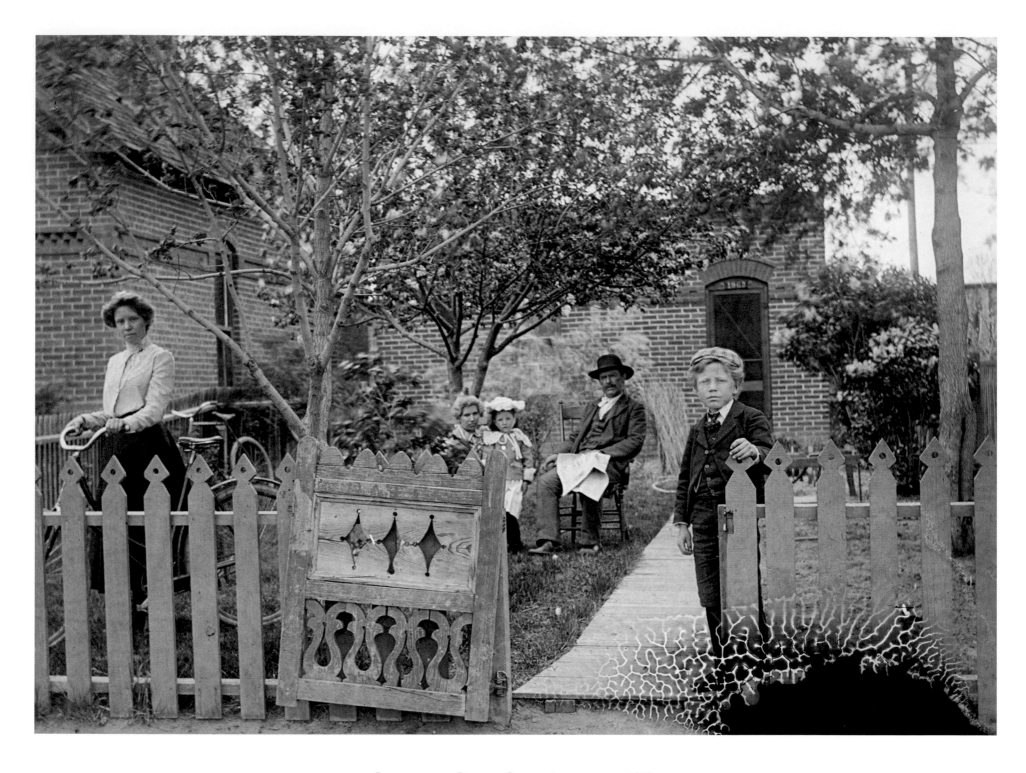

Family in yard, Denver. Charles Lillybridge, c. 1910

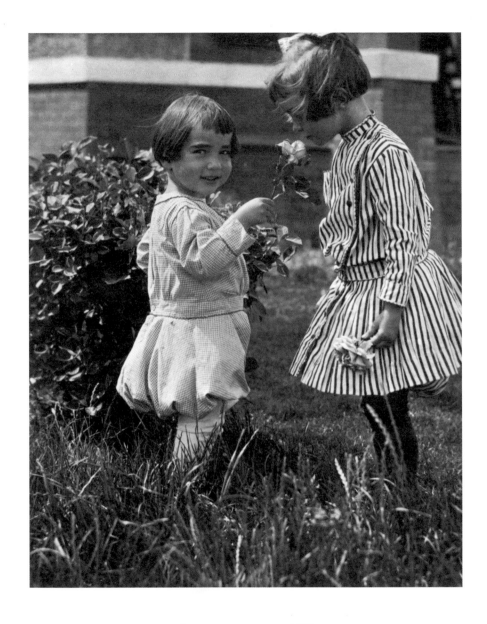

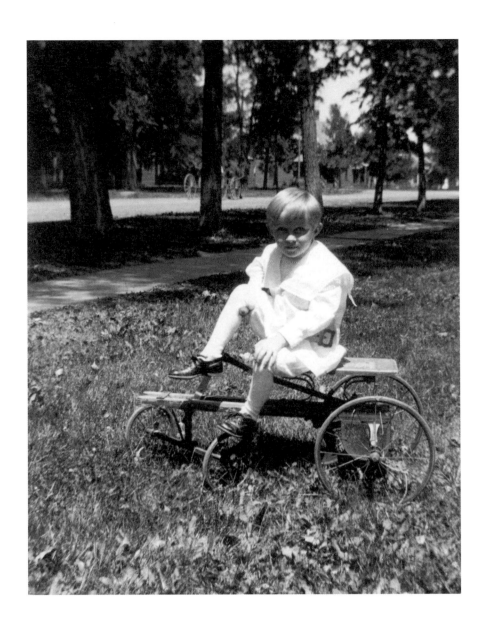

SMELLING FLOWERS, C. 1905

*ON REVERSE SIDE OF PRINT:* "JIM SITTING ON HIS IRISH MAIL," C. 1905

# ON STREET & ROAD

Y*ou could go practically anywhere your two feet would take you—along the prairie, up hills and mountainsides, into fields thick with corn or wheat, or through a neighbor's backyard. All of it was an adventure, all of it exploration. The trails you blazed on the open ground belonged to you and your friends, even if these paths were no more than secret shortcuts to someone's house. But the rest of the world followed different avenues of passage—and these were the dirt roads or hard-surfaced streets that carried horses and buggies or automobiles from one place to another. Depending on where you lived, they could be serene and open, or fast and dangerous. You might wander down a country road without fear, but in the city you had to look for traffic at every turn. Even so, you spent many a day along the roads and in the streets—playing, walking, watching the world go by, and sometimes marveling that the very road on which you stood touched some distant place.*

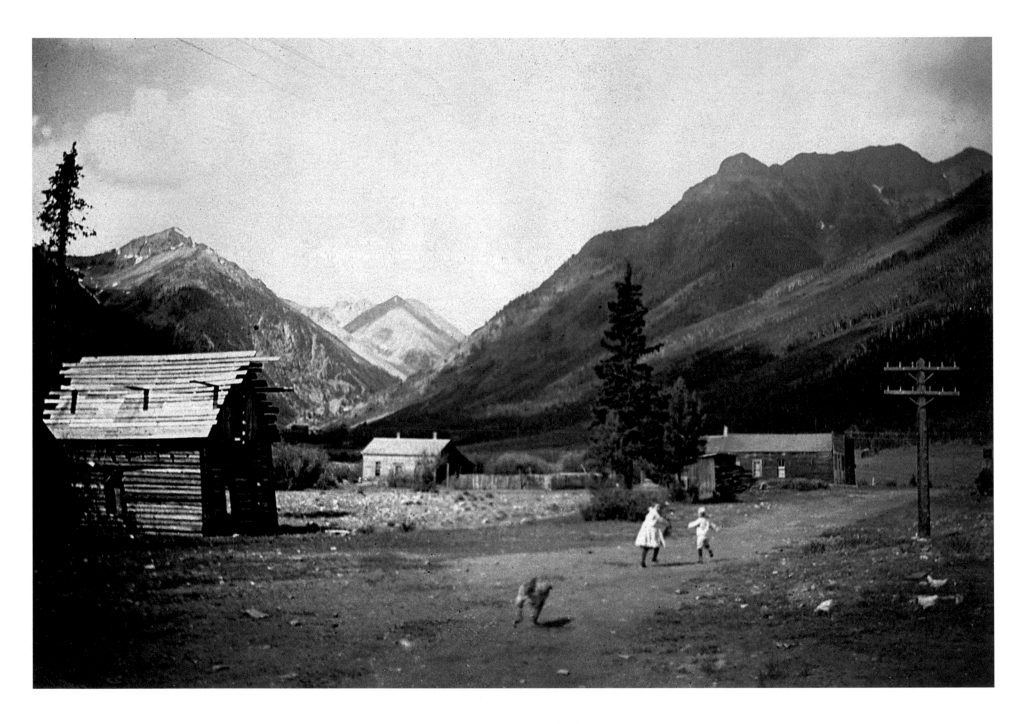

Mountain chase, c. 1900

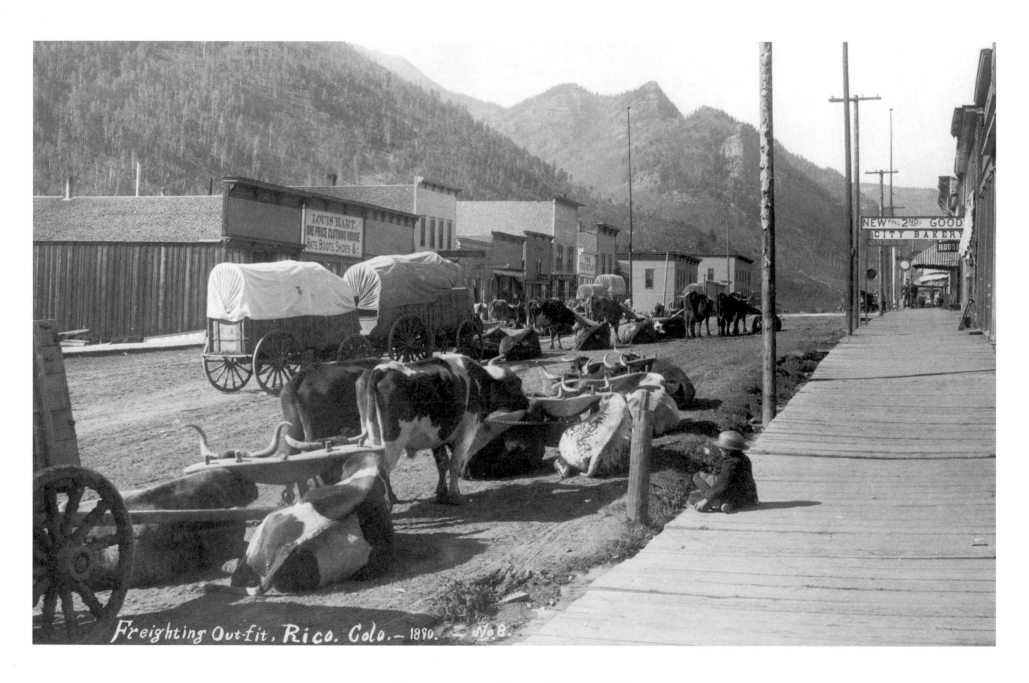

Freighting Out-fit, Rico. Colo. — 1890. — No 8.

Rico street scene.  Charles Goodman, 1890

Cañon City street scene. Royal Hubbell, April 1896

 # OTHER CHILDREN

*Usually, you only noticed other children when you were away from your own neighborhood or school yard, in a place where everything seemed a bit unfamiliar. If you were with a group of friends or members of your family, the children around you became little more than objects of curiosity, passing glimpses of this or that kind of face, look, outfit, or gesture. But if you were alone, you watched other children almost by instinct. They might be bigger than you—and unfriendly. Or doing something you wanted to do. Or alone like yourself, and watching you in return. They might look like they belonged there, or they might look out of place.*

*Then, once in a while, the sight of another child could really set you to wondering. What if you were standing there in her place, or his? How would things look to you? Where would you live and what would you do every day? And then: What if your parents died and left you an orphan? What if you ran away from home or suddenly became very rich? What if you got dangerously ill and had to stay in a hospital? Or went blind? Or grew up in a strange family across town?*

*Looking at some children, you sensed your world and theirs would never meet except in a momentary glance, and that glance made the world seem bigger and less familiar than it was before.*

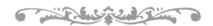

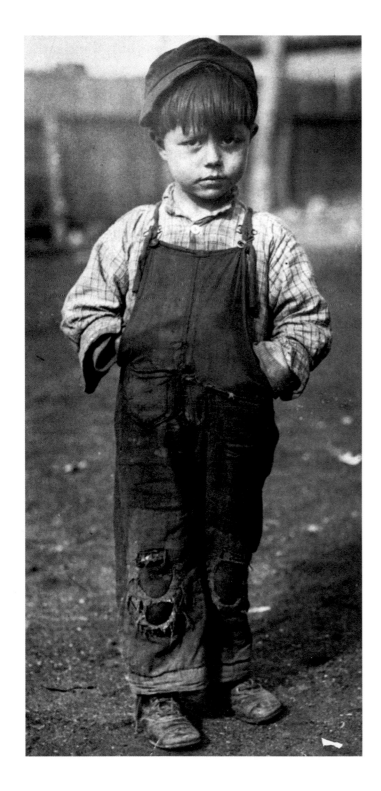

TATTERED CLOTHING, C. 1910

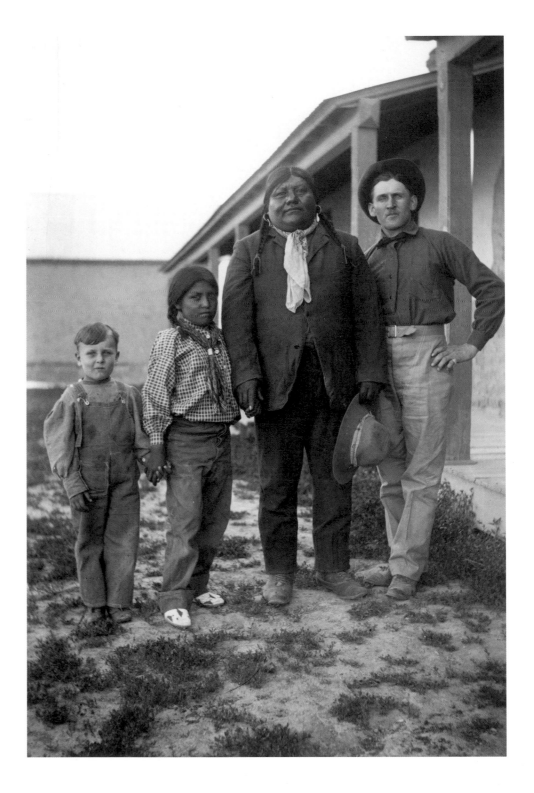

UTE INDIAN PETER MONK WITH SON AND FRIENDS, SOUTH OF CORTEZ, 1908

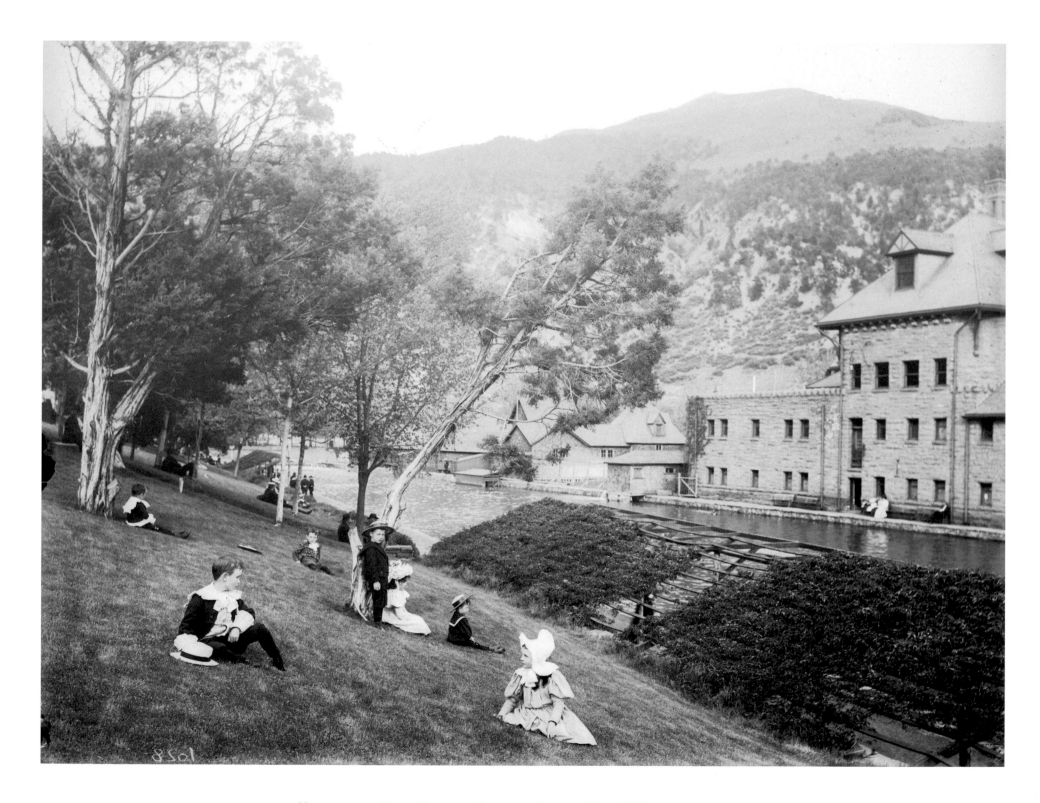

Hot springs at Hotel Colorado, Glenwood Springs.  Harry H. Buckwalter, c. 1895

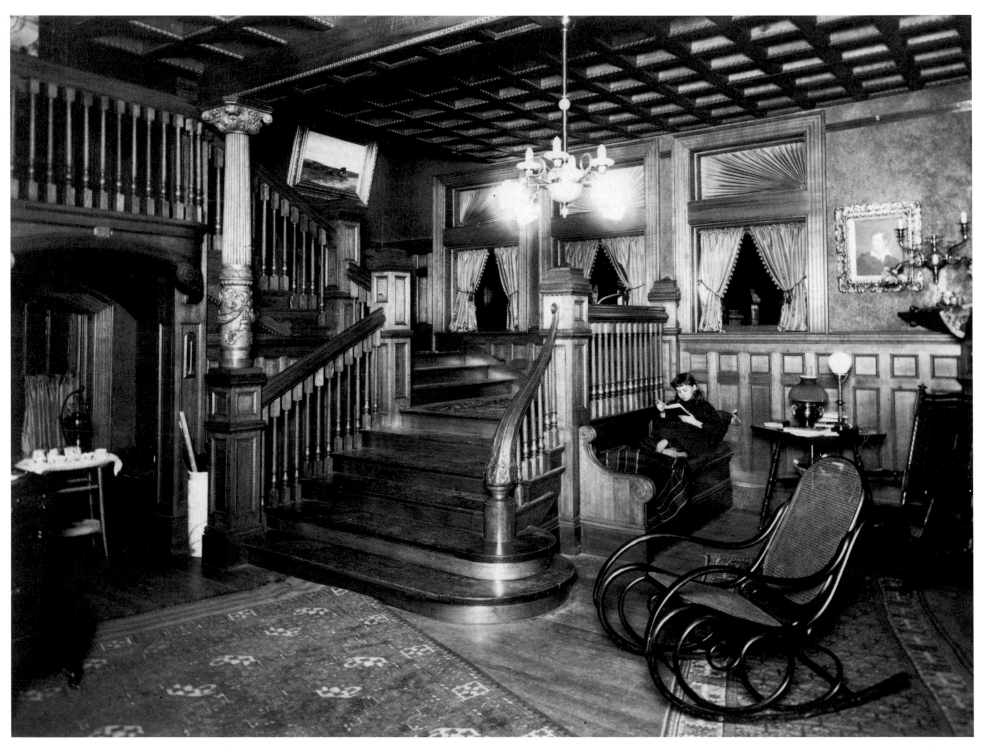

RESIDENCE OF DR. C. N. HART, FOURTEENTH AND HIGH STREET, DENVER, C. 1890

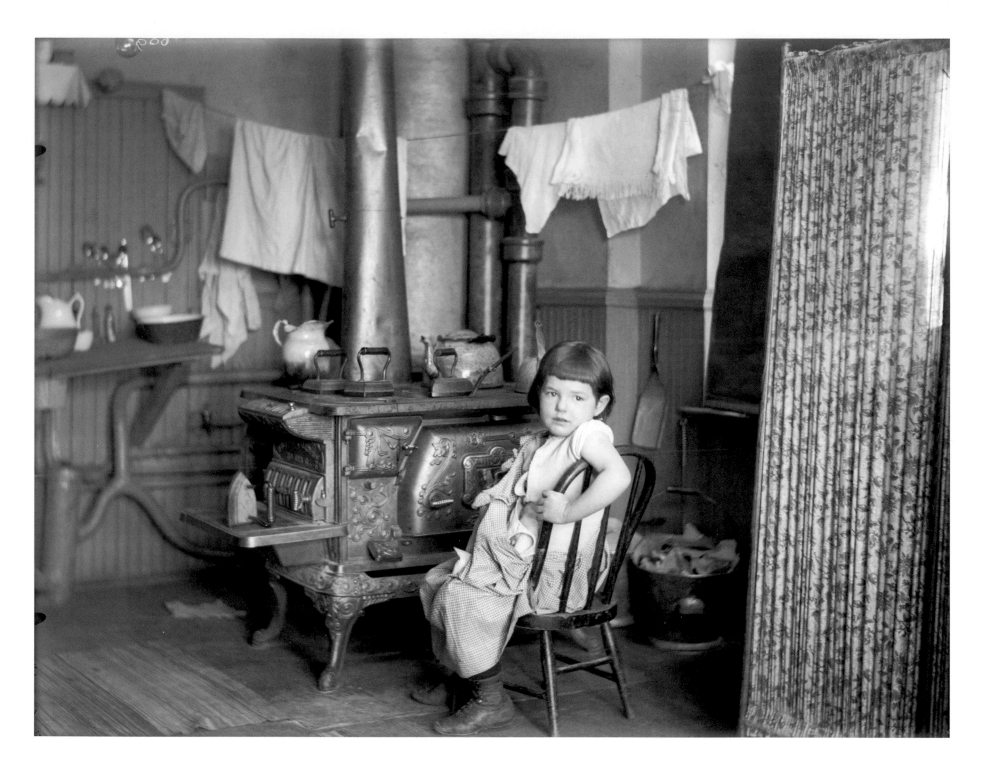

"Lillian," State Home for Dependent Children, Denver. Harry H. Buckwalter, January 1901

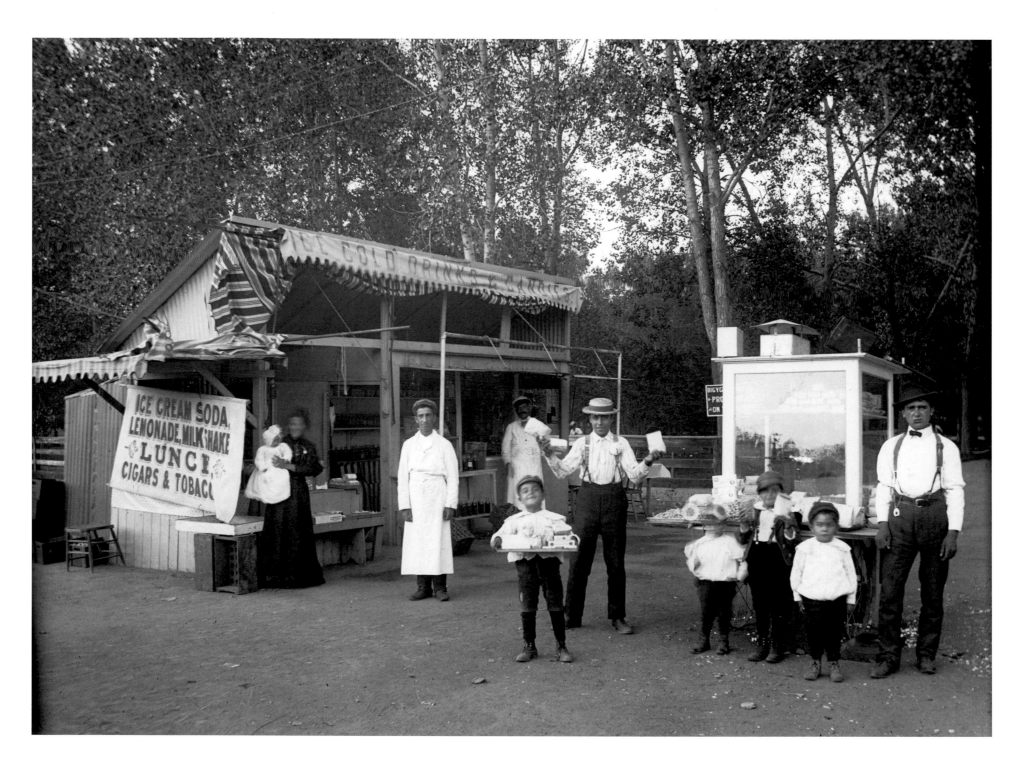

Vendors in a Denver park. **Charles Lillybridge**, c. 1905

# A GIRL'S LIFE AT THE TURN OF THE CENTURY

Most of the children pictured here are nameless, but none is truly unknown. They each have a private history, remembered in some way—and to some degree preserved—by these historical images. Any number of images here might lead us to wonder who these children were and what their childhood lives were like. If we could select one child, one private history of childhood, among all the others, what would it reveal? Once we raise this question, even if we are drawn to a particular child by the power of the anonymous image, it is no longer possible to rely on recollection or imagination to satisfy our need for an answer. Suddenly, the facts of someone else's experience become compelling in themselves, and these can only be known by the legacy of an individual life, including personal possessions handed down from one generation to another, private documents, family photographs, and public records.

In a sense, it was accidental that, along with a sizable collection of photographs of Colorado children, we at the Colorado Historical Society held in public trust the visual record of one child's life. Even more remarkable is the fact that Irma Bartels' death at age 12 rendered her biography not only the story of a life, but of childhood as well.

Upon Irma's death in 1901, her childhood possessions—clothing, jewelry and trinkets, school notebooks, calendars, dolls and games, photographs of herself and her family, and other personal effects—were placed in a trunk bearing her name. The trunk stayed within the immediate family for nearly three quarters of a century. Then, after the death of Elsa Bartels (Mrs. Arthur F. Hewitt), Irma's sister, it was bequeathed to her son, Arthur F. Hewitt, Jr. Mr. Hewitt donated the trunk and its contents to the Colorado Historical Society in 1975. Altogether, it is a rich resource of personal objects and images that yield, through historical research, a singular picture of childhood in Colorado.

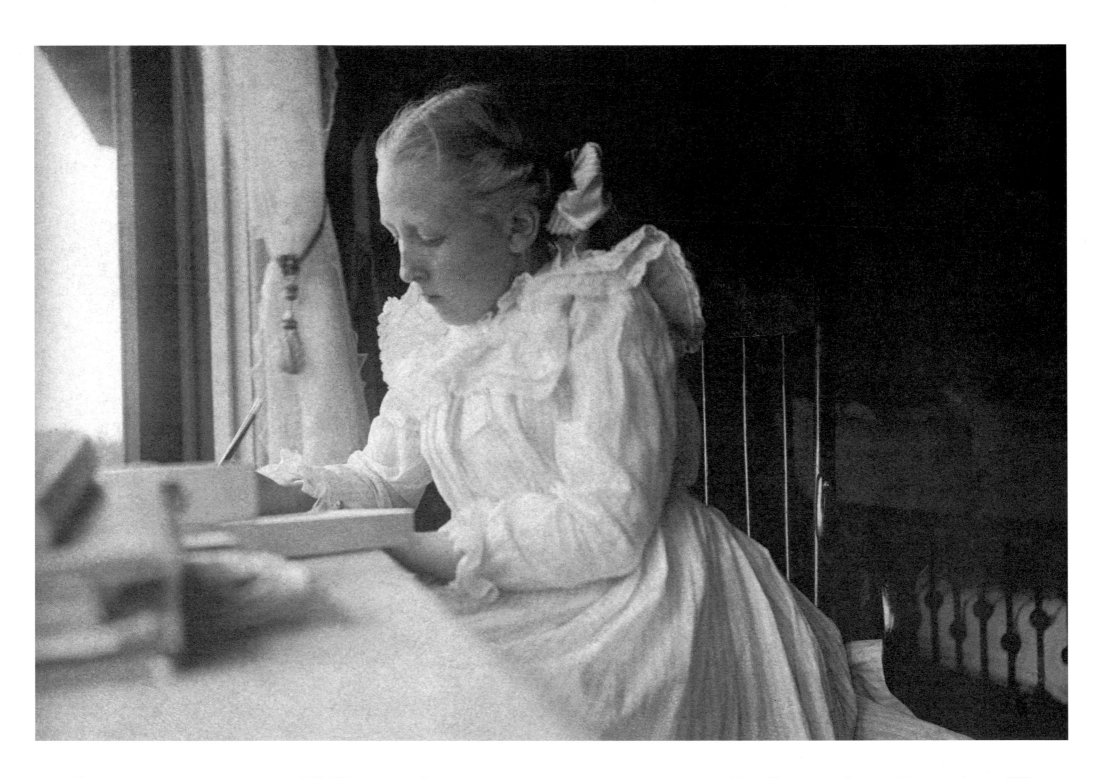

Historical photographs for this section, 1888–1901, taken from Bartels trunk; contemporary photographs of artifacts by Myron Tannenbaum, Colorado Historical Society, 1982

# THE STORY OF IRMA BARTELS

Irma Louise Bartels was born at noon on Good Friday, March 30, 1888. Her mother, Carrie L. Bartels, who went by the name of Caddie, gave birth amid the sounds and shouts of a parade passing by the house. Married slightly less than a year, she lived with her husband, Louis, in a row house at 813 20th Street. Denver was celebrating the completion of yet another railroad line—the Denver, Texas & Gulf—and the festivities outside may have seemed to Caddie a particularly appropriate way to honor the birth of her first child.

Caddie Crandall and Louis Bartels had both been students together at East Denver High School 10 years before. At that time, Caddie had recently left her family home in Warren, Illinois, to live in Denver with her sister Adella and her brother-in-law, Clarence H. Olmsted. Eight years later she was still living with the Olmsteds when Louis Bartels left his brother Gustave's law office to go to work for Olmsted in the real estate and loan business. Most likely Louis and Caddie became acquainted—or reacquainted—through Clarence, and on June 15, 1887, she and Louis were married in the Olmsted home by the Reverend Henry A. Buchtel.

As close as she and her sister were, Caddie must have been surprised at all the gifts Adella lavished on the new baby. Aside from a complete infant wardrobe—including shirts, stockings, shoes, hood, dress, bonnet, and cloak—Adella presented baby Irma with two dolls, a rattle, and a bassinet. From other friends and family members, the baby received flowers, blankets, a quilt, and personal valuables to use and treasure as she grew up. One of these was a silver drinking cup, a gift her grandmother Caroline presented in the name of Irma's grandfather, Louis F. Bartels, who had been a prominent merchant in early Denver before his death in 1874. Another gift from Grandmother Caroline was a pin belonging to the youngest of her seven children, Alma, who did not live beyond Irma's first year.

Around the time of Irma's birth, her uncle, Clarence Olmsted, was involved in the completion of a project he helped finance: the construction of Trinity Methodist Episcopal Church at 18th Avenue

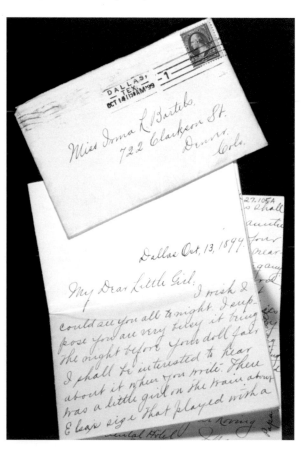

and Broadway. It is hardly surprising, then, that the first child christened in the church was Irma Bartels. Reverend Buchtel and Bishop Henry W. Warren performed the ceremony on December 23, 1888. In naming the child, no doubt, the clergymen used the traditional German pronunciation, with the initial "i" sounded as a long "e" as in "Ear-ma," according to Louis' wish. This, according to Caddie, was the only name by which her first child was known. When the next child, Elsa, was born in October 1890, however, Irma gave her the pet name of "My," which the whole family adopted.

Whatever My may have meant to Irma, who was then two-and-a-half, it could not have been far removed from the sense of loving possession she felt for her dolls. She may still have had the rubber doll and the Chinese doll that Adella had presented as shower gifts, and in the past year she had been photographed holding a little stuffed black doll. In fact, shortly after Elsa's birth, when the family went to the Albert E. Rinehart Studio in Denver for an early photograph of the two sisters, Irma brought one of her dolls along to make it a portrait of three.

As the two girls grew up, both continued to be interested in dolls, and their mother readily made use of their pretend world to express her own caring and love for her children. Once, when one of Irma's dolls

was damaged, Caddie had it repaired and sent a charming note to Irma—addressed to Mrs. I. L. Bartels—in the doll's name. While being fitted for dresses in Madame Bell's shop, the note read, the little doll had been struck by a falling piece of plaster. Although the hospital physician and nurses managed to save her life, the trauma had changed the color of her eyes. "Now my dear mother," it continued, "I

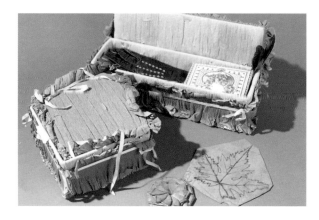

hope this change in my looks won't make any difference in your love for me, for I love you just the same and I am always your own little Dorothy."

By the time Irma was of school age, the First District, which encompassed east Denver and outlying areas, began offering a kindergarten department in a few of its schools. These kindergarten classes provided up to two years of preschool training. Caddie, who once taught primary-grade children, took immediate advantage of this by sending Irma, at five, to the new kindergarten at Corona School (now Dora M. Moore), which was close to their home on Washington Street and Fifth Avenue. Here, among other things, Irma learned how to thread colored strips of paper into highly geometrical designs, a process believed by educators of the day to be essential in preparing young minds for disciplined study and thought. Elsa may also have joined Irma in kindergarten at Corona, but she first appears on the

school records at Wyman, where the girls were enrolled in 1895 following the family's move to 1200 Vine Street.

This move launched a three-year period of frequent change for the Bartels children. They had hardly become settled in one neighborhood when they had to move again. Possibly, Louis Bartels, now a partner in the real estate and insurance firm of Bartels Brothers and Bishop, saw the advantages of improving and selling one house after another. Or, possibly, Louis and Caddie had not yet found the ideal home. Whatever the case, the Bartels girls undoubtedly came to know the childhood hardship of leaving neighborhood friends and facing new schools, in spite of the comfort and well-furnished security their substantial houses provided.

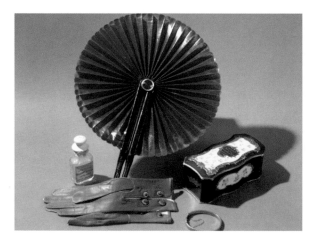

Thus, in the fall of 1897, the girls were transferred once again, this time to the Eleventh Avenue School. The school's temporary building testified to the rapid expansion of the city eastward and of the overcrowding at Wyman, which had only 648 seats but was approaching a student enrollment of 700.

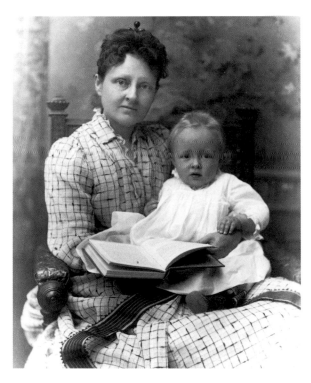

The Bartels family had recently moved to 1342 Columbine Street, only two blocks from the new school, but the girls' attendance at the modest schoolhouse was short-lived. At the end of the second term, in late March 1898, they were again transferred, this time back to Corona School, which was near the family's new home at 677 Emerson Street.

After completing the third grade at Corona School in the spring of 1898, Irma was allowed to bypass fourth grade and start school again the next fall in the fifth. Little, if anything, can be found in her schoolwork to explain such a promotion except, perhaps, the evidence of her later skill in written

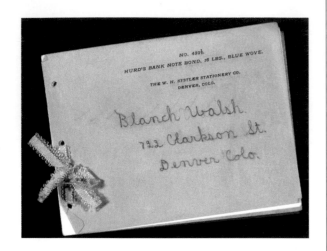

German. Irma may have gained an early advantage at home in this subject, influenced by her father's sense of tradition and ethnic pride. She often found occasion to write small reminders to herself in old German script—sayings such as, "Modesty is the loveliest dress," "All that glitters is not gold," and "Sincerity comes from the heart; sincerity also comes from the mouth."

Irma's work in the fifth grade—especially compared to Elsa's in the third grade for the same year—hardly warranted such a promotion. Though no record survives of the monthly grades Irma received from her teacher, Flora Thompson, her composition books show that she had not yet mastered the more conventional principles of grammar, spelling, punctuation, or capitalization. Her handwriting itself ranged from hasty but readable back-slanted characters to an almost illegible scrawl, and at times it changed so radically that it might have seemed to Miss Thompson to be hardly the work of the same person. What Irma may have been feeling or experiencing during these times is idle speculation, but her writing apparently shows her to have been rather impatient, careless, and prone to casual mistakes in her schoolwork. By the sixth grade, Irma's writing had become more even and consistent, but she was

still having problems with her assignments. Her grades on the whole were above average (though slightly) and her new teacher, Anna Ryan, gave Irma her highest marks in penmanship—perhaps for improvement—and second highest in geography, a favorite subject. One of her school assignments was to draw a memory map of Colorado, and while its central mountain range too neatly boxed the high meadow parks and a few Western Slope towns were misplaced, Irma did impart a general sense of geographical orientation. She also tried her fledgling artistry on reports about other countries.

Still, it must have been apparent to Irma that she was not the student Elsa was—neat, self-assured, and correct. If this bothered her, especially since she was the eldest child, Irma could at least feel confident

that her mother would not compare the two sisters unfairly. In a letter Caddie wrote to the children from Dallas, Texas, in October 1899, she openly recognized Irma's privileged position as the ranking child and may have even unconsciously identified with her when she apologized for the quality of her own writing. Caddie, accompanying Louis to a convention for insurance agents, directed her first letter to Irma. Exhausted by the convention activities and facing a

number of social invitations, Caddie explained that she had decided to stay in her hotel room that evening and "write to my little girl." Though Caddie produced a masterful piece of correspondence, full of news, anecdotes, motherly advice, and wry humor (as in her closing line, "Don't forget the name—Mrs. L. F. Bartels"), she at one point assumed the role of an erring child. "I am so tired tonight," she said, "that I can scarcely write at all. I will have to do better than this when I write to Elsa or that young lady will turn up her nose. I know you can sympathize with me and excuse it if I promise to do better next time."

It had not taken Irma and Elsa long to make themselves comfortable in the new neighborhood near Corona School. A fourth move in mid-1898 had hardly been disturbing—only one block west on Seventh Avenue to 722 Clarkson Street, into a home they shared with their Aunt Adella and Uncle

Clarence. Within a year, they counted other adults among their friends as well as several children. In May 1899, for example, Irma received a small gift from Frances Mack Mann, the mother of her eight-year-old friend Paul Mann, who lived on Washington Street. Mrs. Mann, a reader at the First Church of Christ, Scientist, in Denver, gave her a tiny book of scriptural verses entitled *Golden Truths*, inscribed to Irma with love.

Even closer to the girls was Mrs. John Mitchell —or "Aunt Clara," as Irma called her—a friend of Caddie's and the mother of Clark and Clara Mitchell. In the Mitchell home, Irma attended regular meetings of the neighborhood club, a combination of conspiratorial fun (including a secret code) and public-spirited projects. In November 1899, for example, the children of the club, led perhaps by Clark and Clara, prepared a fair to assist the Poor Fund for Christmas—an idea that could well have originated with the doll fair Irma and Elsa had hosted a month earlier.

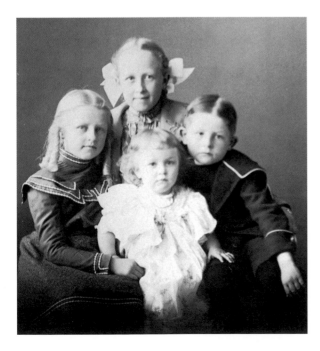

Clark was a year older than Irma, and Clara was two years younger, but the age differences seemed to have had little effect on their relationships. They played together often, ate at each others' homes occasionally, and shared special times, such as Irma's 11th birthday in March 1899, when Clark brought his camera over and took several photographs of her as a birthday gift. Clara would join Irma and Elsa when they went to Saturday matinees at the Tabor Grand or the Broadway Theatre, and it was probably a rare occasion when Clara did not join the girls for big events, such as the Saint Patrick's Day parade, which Adella took the children downtown to see.

Few friends of the Bartels girls, however, lived as near to them as did the Mitchell children—right across the street on Seventh—and in visiting other neighborhood playmates, Irma must have become well acquainted with the 30-block area around her home. Though many of her friends lived within walking distance, she probably chose to ride her bicycle, particularly when she went to see friends such as Margaret Scott or Suzie Ward, who lived on Corona below Sixth Street, or Helen Bennett, who lived three blocks south on Washington. And since the Bartels household as yet had no telephone, she might even have felt energetic enough to ride over to her old neighborhood near Cheesman Park to see Anna

Farrar, who remained her good friend even though they lived some distance apart.

At other times, children on the block would all gather together at one place for some spontaneous fun. During an especially busy week in March 1900, Irma spent almost every afternoon with one group of friends or another. On a Tuesday, as she recorded in her date-book, Helen, Margaret, Clark, Clara, Flora Deane,

who lived up the street, and unidentified girls named Olive and Margaret joined Elsa and Irma in the hide-and-seek game Run, Sheep, Run. The next evening, she and some of the other children built a bonfire, and on Thursday she attended a meeting of the club. On other days—and with fewer children, most likely—she spent quieter moments playing Lotto, making candy, constructing frilly crepe vanity boxes, or returning once again to her ever-present dolls.

By the time Irma and Elsa hosted their doll fair in 1899, two more children had entered the Bartels family. Louis Frederick, Jr., six years younger than Irma, was now approaching kindergarten, and Gertrude Amanda, not yet two years old, was the baby of the family. Caddie may have watched Irma bestow the same motherly affection on Gertrude that she had earlier given to Elsa—and perhaps the same kind of make-believe propriety expressed in her well-worn book *Afternoon Tea*. In terms of age and

interests, however, the two older girls had more in common with each other than with the younger children. Perhaps because of her close association with Irma, Elsa was a mature young girl by age nine, and the two of them shared the same friends, sat through each other's piano lessons on Saturday morning, and even occasionally dressed alike. It must have pleased Caddie to see such a bond developing between her two daughters, because she had always enjoyed a similar relationship with her own sister, Adella.

By 1900, though Irma was still interested in dolls of all kinds and in outdoor games, her childhood fantasies were assuming a new character. Along with the paper dolls and valentines, she was starting to collect richly brocaded calendars and fans, and she took to cutting out letterhead monograms that were

attractive marks of wealth and prestige. She might once have wished herself to be the adventurous young girl who traveled to the Chicago World's Fair in *Two Little Pilgrims' Progress*, a birthday gift from her Aunt Lina. But now other figures attracted her, and she cut out and saved a magazine photograph of Wilhelmina, queen of the Netherlands, who was eight years her senior and bore a striking resemblance to the young Denver girl. Although Wilhelmina was a distant and romantic image of royalty and splendor, at least one woman closer to home had achieved the

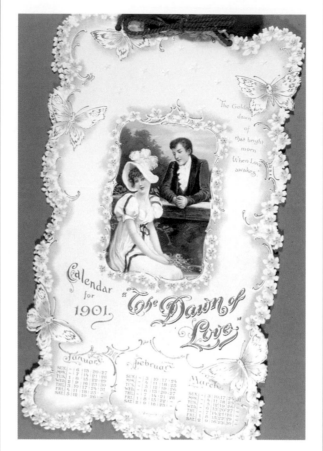

kind of fame Irma could identify with directly: the American actress Blanche Walsh. Walsh, a New York performer who spent a year in Denver in 1898 as the leading lady of the local Manhattan Beach Stock Company, returned on tour in 1900 to star in four of Victorian Sardou's elaborate productions: *Cleopatra*, *Gismonda*, *La Tosca*, and *Fedora*. Walsh had the added distinction, in Irma's imagination—and neatly captured on a beribboned slip of paper—of being one and the same as the young girl who lived in Denver at 722 Clarkson Street.

Irma's developing awareness of society and her place within it, however, was more directly guided by the example and practice of her mother and her mother's peers. She was old enough to send and receive invitations, to go riding with her aunt Lina, to

correspond with her other aunts and her mother's friends, and to buy the materials she needed for personal projects, schoolwork, and social activities. And while it may not have been proper yet for her to carry printed calling cards, she made some of her own just the same—in her most careful hand—and used a sealing wax set complete with a stamp bearing her initials.

In another respect, Irma shared with her mother a devotion to a deeply felt religious life. During the eight years before her marriage that Caddie lived with the Olmsteds, she most likely accompanied Clarence and Adella to the early Methodist Episcopal Church. There is no record, however, of her ever having been confirmed in this faith. In 1896, when Irma was eight, Caddie was baptized by a minister of the Disciples of Christ. Such a late baptism—Caddie was then 36 years old—speaks compellingly of a decisive spiritual commitment she made for herself and possibly for her children. For Irma, the new church would not itself have seemed radically different from any other that she may have attended. Central Christian was dutifully Gothic in

its design and Protestant in its doctrine. Its message of witnessing for Christ resembled most other Christian churches in an age when the gospel was allied with an equally strong faith in the betterment of civilization.

Irma, a member of the church youth group, came to be an active participant in the Christian Endeavor movement, an interdenominational effort to instill Christianity into the business and social lives of Americans everywhere. She was apparently a conscientious Bible student and a promising young disciple.

Some of Irma's companions at church may well have been invited to the elaborate after-Christmas party

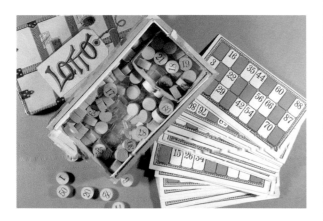

that Irma and Elsa held for all their friends and cousins in late December 1900. Even with a few cancellations, almost 50 children arrived—the *Rocky Mountain News* even found a place for the event in its society column. The party was based on the theme of geography (one of Irma's favorite subjects), and the boys and girls competed for prizes in a "geographical contest."

In contrast, Irma's cousin Earl, Gustave's 17-year-old son, gave a holiday party of his own with music and dancing. Although the newspaper also termed this a "children's party," it would not have been appropriate for Irma to attend, even though she was nearing 13, and Earl was too old to attend hers. Instead, the quasi-educational theme of her party provided a good rationale for bringing boys and girls together socially, and its well-structured activities were undoubtedly organized and monitored by Caddie and Adella.

This party was, however, the last time many of Irma's friends would ever see her. For barely two weeks later, Irma caught a winter cold that quickly turned into pneumonia. After a night-long struggle, she died at noon the next day.

Irma's church newspaper, the *Christian Messenger*, described her as "Central's brightest and best Sunday school and junior endeavor worker" and a model child. This opinion was understandably flattering given the context, and could not have been far from the truth considering how Irma had endeared herself to the adults around her.

On January 6, 1901, the day after Irma's death, some of the children she had known at school attended the private service at the Bartels home and sang as a quartet under the direction of her music teacher, Margaret Utter. The presiding minister was probably the Reverend Bruce Brown of Central

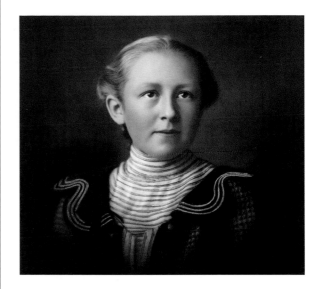

Christian, but none of the other mourners, young or old, have been recorded—except for Mrs. John Mitchell, whose calling card Elsa accepted on the day of Irma's death and dated for her mother to keep.

In the days that followed the funeral, Caddie—possibly at Adella's encouragement—must have agreed to the terrible but inevitable task of going through Irma's belongings to decide what to keep and what to let go. Undoubtedly, she would have gone over each item, thinking not only about Irma but of her daughter's friends, relatives, and others who might want something of her to remember. Those items that Caddie and perhaps other members of the family placed in the spartan trunk bearing Irma's name reflect a remarkably well-rounded picture of this 19th-century child. Still, not many of these objects tell a great deal about Irma's inner life—her likes and dislikes, her private feelings, her beliefs and opinions, or her self-concept. For members of her family, her possessions were merely tokens of a fuller life that they had known, not a summation of that life.

# FRIENDS

When you were with a friend, you never knew what would happen next. Occasionally, you would play with someone who liked doing the same thing endlessly—and even though you might enjoy it for a while, you soon took up with somebody else. It was only with your silent friends—your dog or your doll—that you could spend what seemed like hours at the same kind of play.

But with a real friend, you always felt that something new was just around the corner, and either one of you could come up with it. Not all of these ideas turned out well—and some could get you in trouble—but usually you were ready to go along with anything that was unfamiliar. Quite often, some game was already going on outside, and you joined in for as long as you were interested. But there always came a time when you had to decide whether to stay with your friend or go and do something else. And when there were two or three others, you were either all together or taking up sides over what to do next.

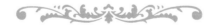

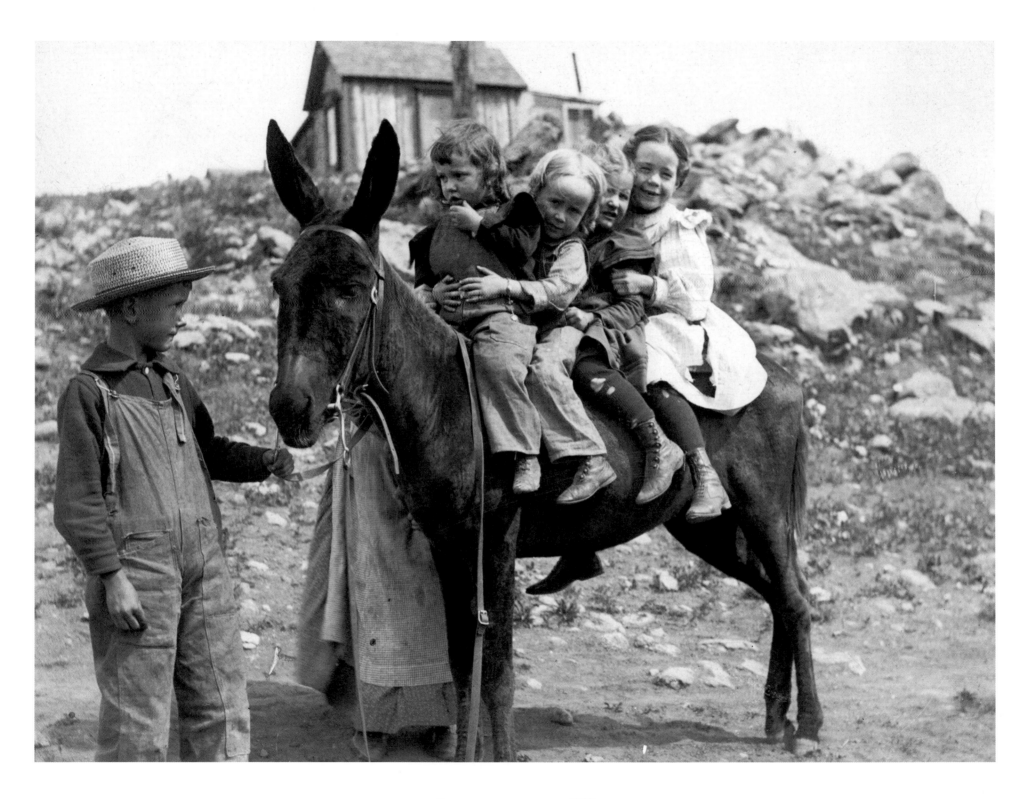

Children with burro, c. 1900

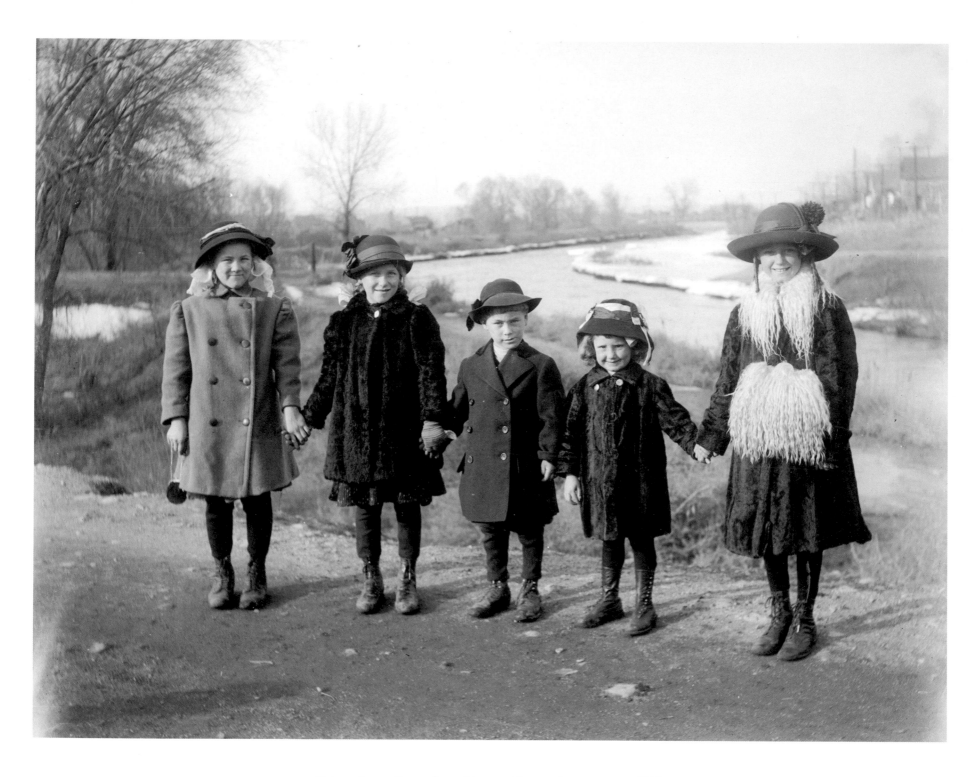

On the South Platte River, Denver. **Charles Lillybridge,** c. 1910

EUGENE C. NAVARRO AND FRIEND, C. 1905

# PLAY

*I*f there was one thing nobody could tell you to do, it was play. Of course, your mother or father might say, "Go out and play." But they wouldn't tell you how to do it, or what to do. Your friends could invite you to play—usually to play something—but the decision was always yours. For, within certain bounds, play was anything you really wanted to do, by yourself or with others. The minute someone told you how you must play, even a bossy friend, you would just as soon leave and do something else. For, in the end, play was yours to do with as you wanted—a game of baseball, a tea party, a drawing, a walk through a field, or a game of hide-and-seek. And, for that matter, there was hardly anything you couldn't find to play with, at a moment's notice. A rag could be a doll's dress, a stick could be a sword, or an old, abandoned house a world of mystery and terror. Play was anything your imagination fell upon, and it was not quite the same thing each time.

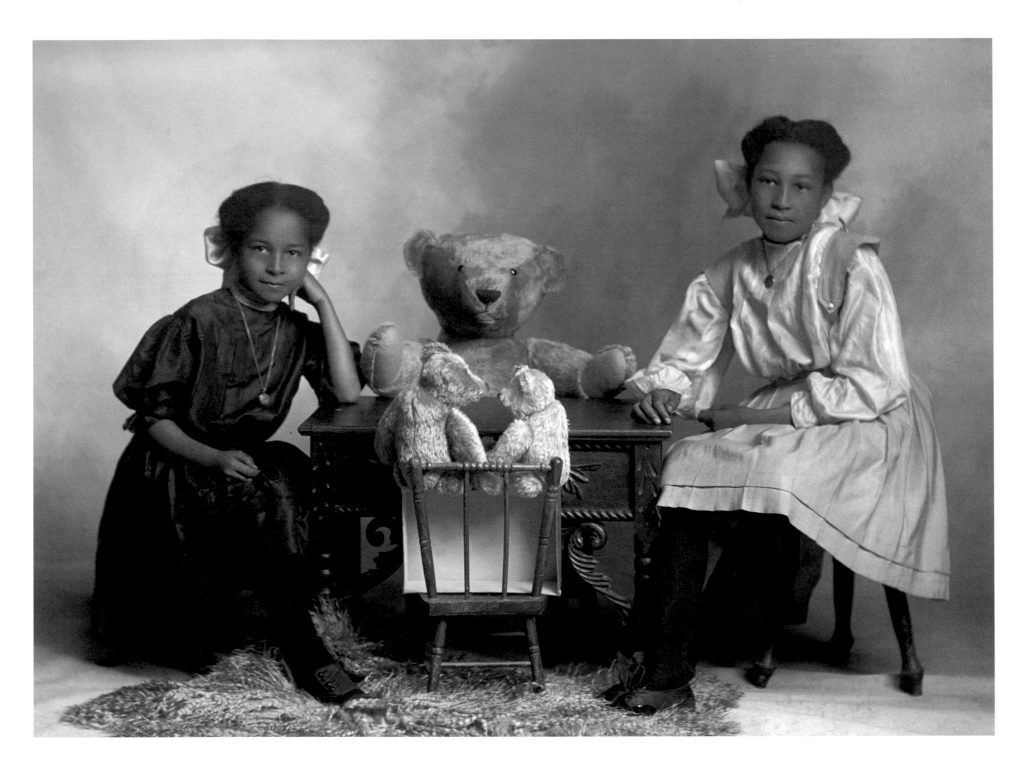

GRAND JUNCTION SISTERS. FRANK DEAN, C. 1905

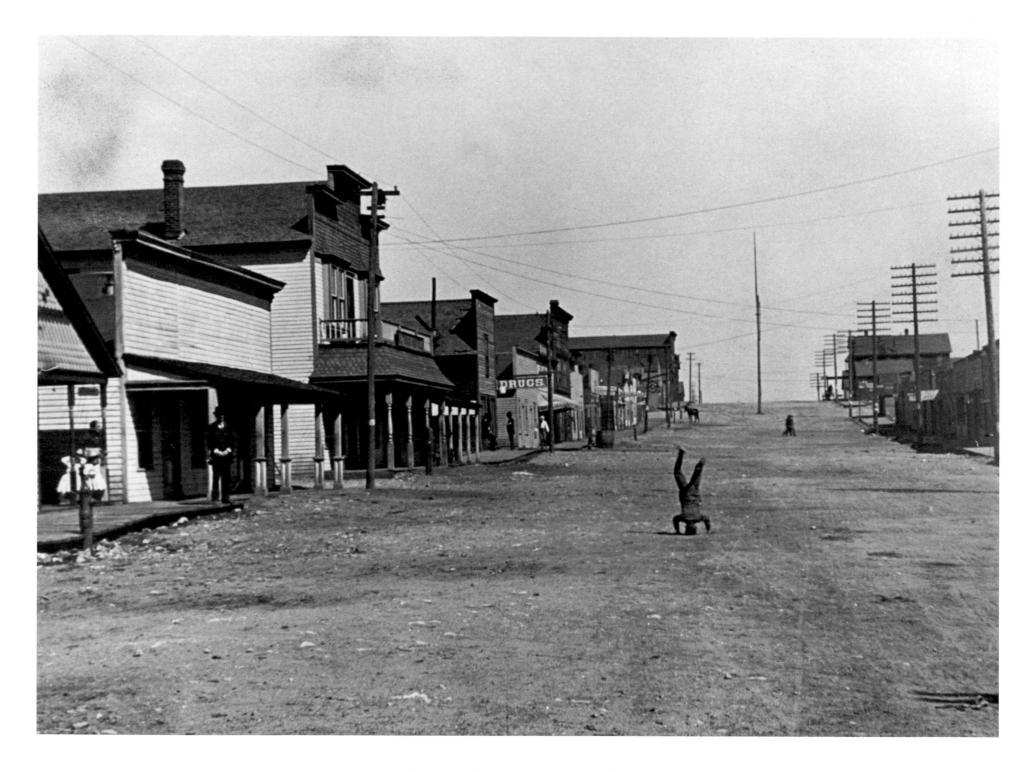

Main street, Altman, near Victor, c. 1900

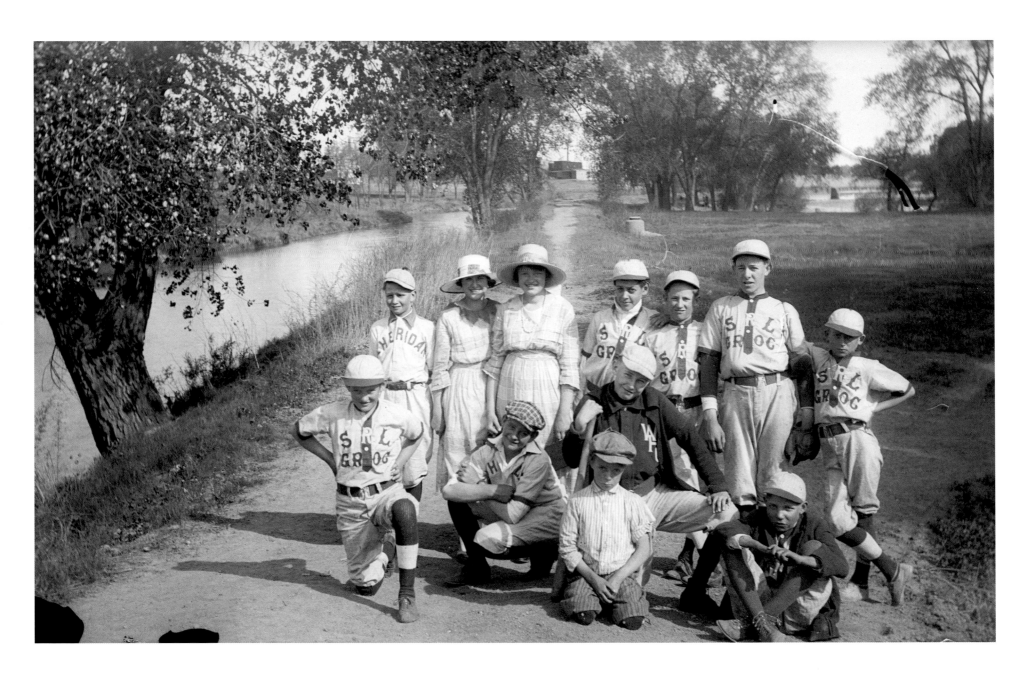

BESIDE THE ARCHER CANAL, WEST DENVER. **CHARLES LILLYBRIDGE**, C. 1914

Boy at 419 Franklin Street, Denver, c. 1927

CLEMENT, RICHARD, AND HAROLD GILE WITH CHARLIE, ESTHER, AND ELIZABETH PARSONS,

COLORADO SPRINGS, FEBRUARY 1898

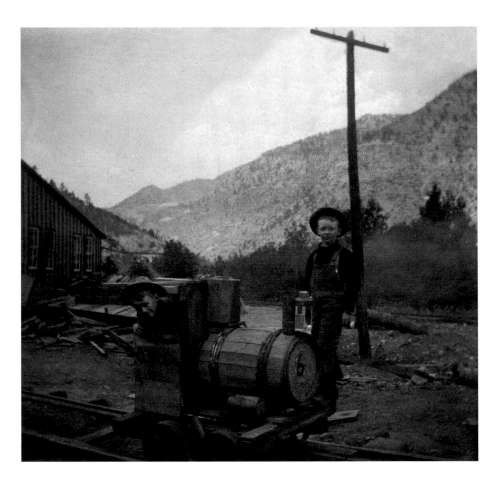

DONALD C. KEMP AND BROTHER ROBERT AT CAPITAL MINING COMPANY, DUMONT,

AUGUST 1900

#  HANGING AROUND

When you went out of the house, you could always expect a call from your mother or father to see if you had done your chores or put on your coat. On warm summer days you might be gone from one meal to the next, and the evidence of your adventures—scuffed shoes, dirty dress, grass-stained trousers, scraped fingers—would surely force you to explain yourself.

On these adventures, you and your friends had the run of the town (if it was small) and nothing was so unimportant that it didn't deserve a few minutes of your attention. Just as often, of course, there was little in particular to do except stand around and look, just waiting for something to happen. And when it did—especially if the event was big enough to draw a crowd—you might spend the whole day there. Then, when you finally got home, no one could stop you from giving them every last detail.

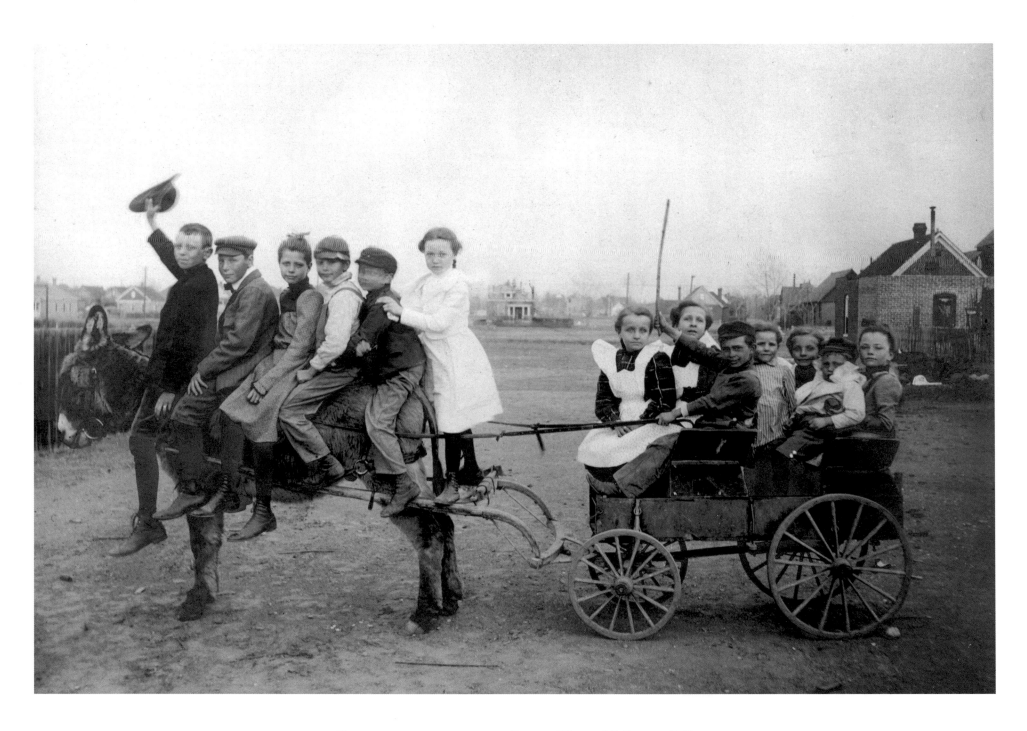

CHILDREN ON BURRO AND WAGON, DENVER. **WILLIAM W. CECIL**, C. 1905

ELIZABETH JEROME, DENVER, C. 1890

STRATTON PARK, COLORADO SPRINGS. **WILLIAM HENRY JACKSON COLLECTION**, C. 1914

DENVER BOYS, CHARLES LILLYBRIDGE, C. 1918

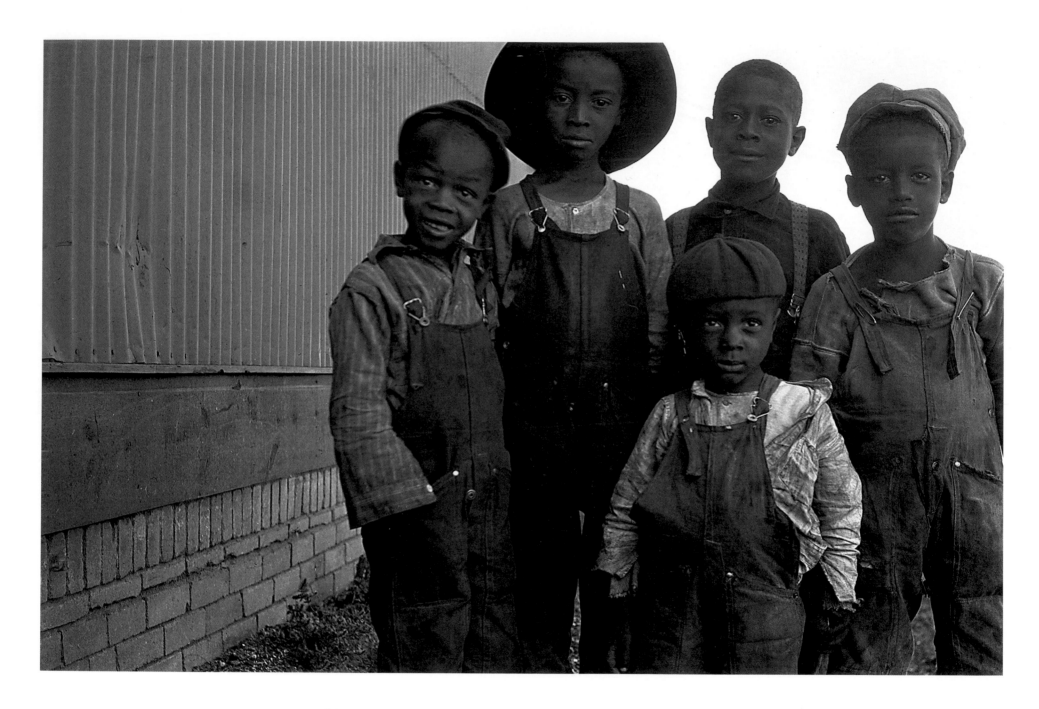

WALSENBURG BOYS, OCTOBER 1906. FROM NEGATIVE ALBUM OF **CHARLES L. BALL**

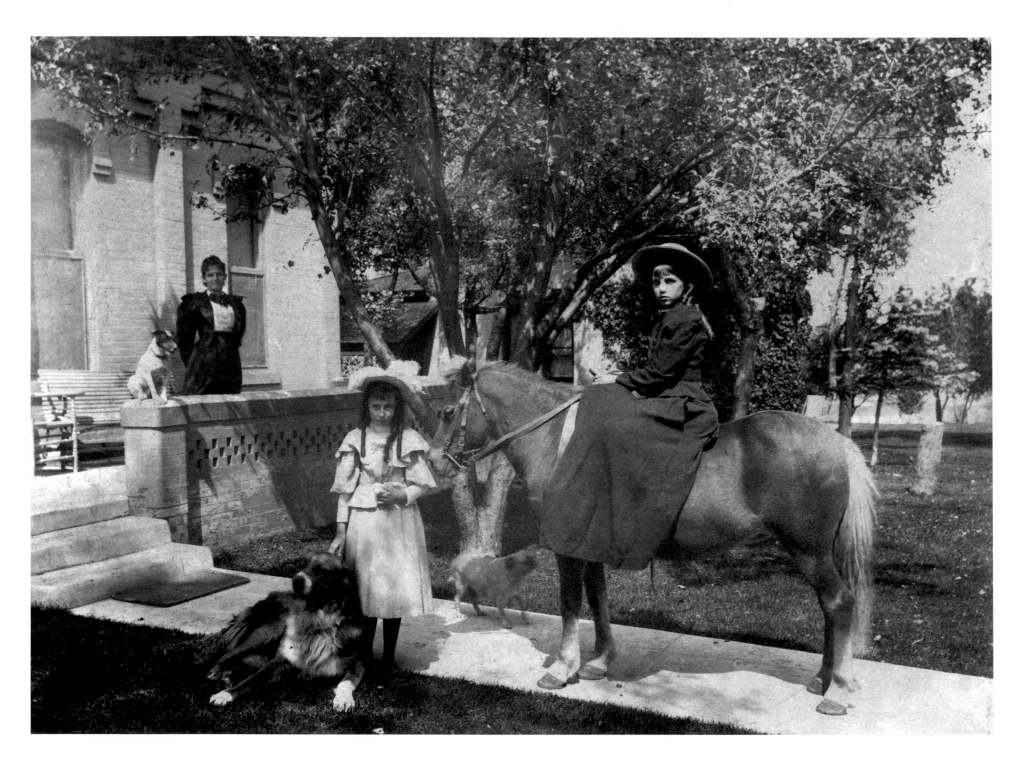

Mary Fleming, Anna Reynolds, and Frederica LeFevre in Denver.  **A. E. Rinehart**, September 1894

# PRETEND

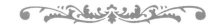

Y*ou might not spend a lot of time thinking about who you were, but you were always finding someone you could become. In fact, you could change yourself into anyone, at any time, with no trouble at all. You simply thought to yourself, or said to your friend, "I'm Buffalo Bill" or "I'll be the Queen, you be Alice." If you could find pieces for a costume or something to use for a whip or a scepter, that was all the better. Even when you were pretending to be someone else, you made that character your own.*

*When you played a part in performances at school or church, it was quite a bit different. Then, you had to be a character they chose for you, and there on the stage, reciting the lines you had memorized, was a person you could not quite become.*

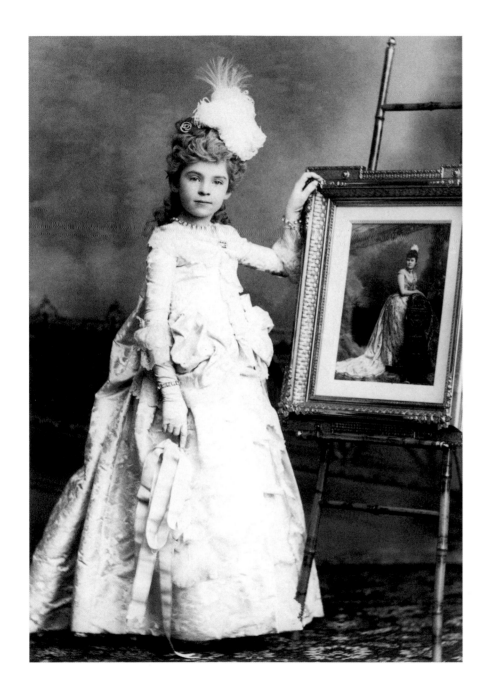

GIRL WITH PORTRAIT, DENVER. **H. WELLS**, C. 1890

BOY WITH ASSAY MATERIALS, CRIPPLE CREEK. **H. D. WEBSTER**, C. 1895

BOY WITH TOP HAT AND CANE, DENVER, C. 1890

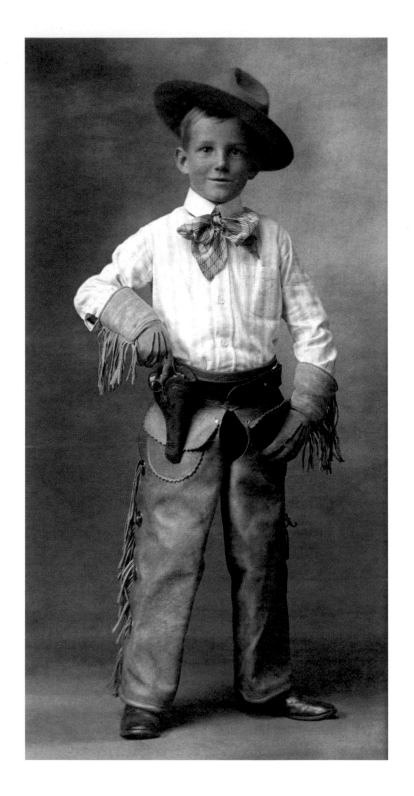

COWBOY, C. 1905

96

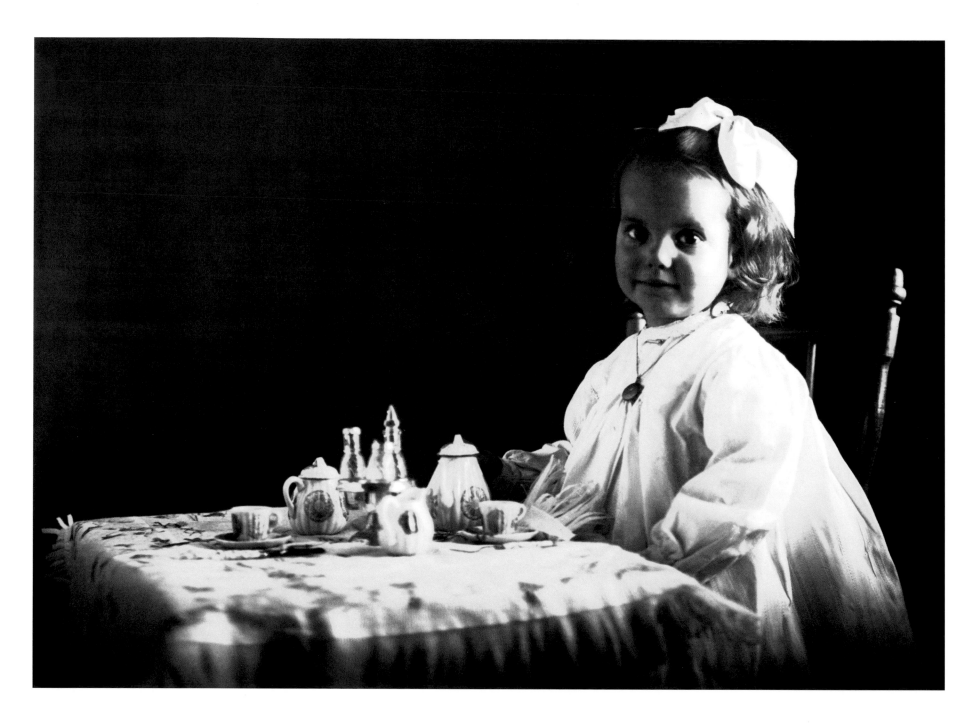

Virginia Downing with tea set, Denver, January 1906

Dorothy Berdeen, Ruth Potts, and Mary Anna Potts, Denver.  **J. G. Potts**, c. 1910

School pageant, Victor, c. 1910

# PETS

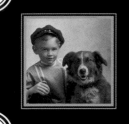

No one could choose your pet for you, or it wasn't yours. But, having chosen it, you had to take care of it. And, in that case, you might as well give it your love. In any case, you probably did love your pet, but even if you didn't, it was nevertheless a friend because it taught you so much about the world. It might be a dog, a cat, or a horse—or even a snake, a pigeon, or a chicken. As you watched it, for what sometimes seemed like hours on end, you began to understand that it lived its own life apart from yours, with its own place in the world, snooping around, looking at things through its own eyes. Then, especially a dog or cat, would come back to you ready for your touch. Often you talked to it—softly, loudly, ordering, begging, or cajoling—or confided in it. At those times, you realized that someday it would be gone, and when that happened, it was a lesson too.

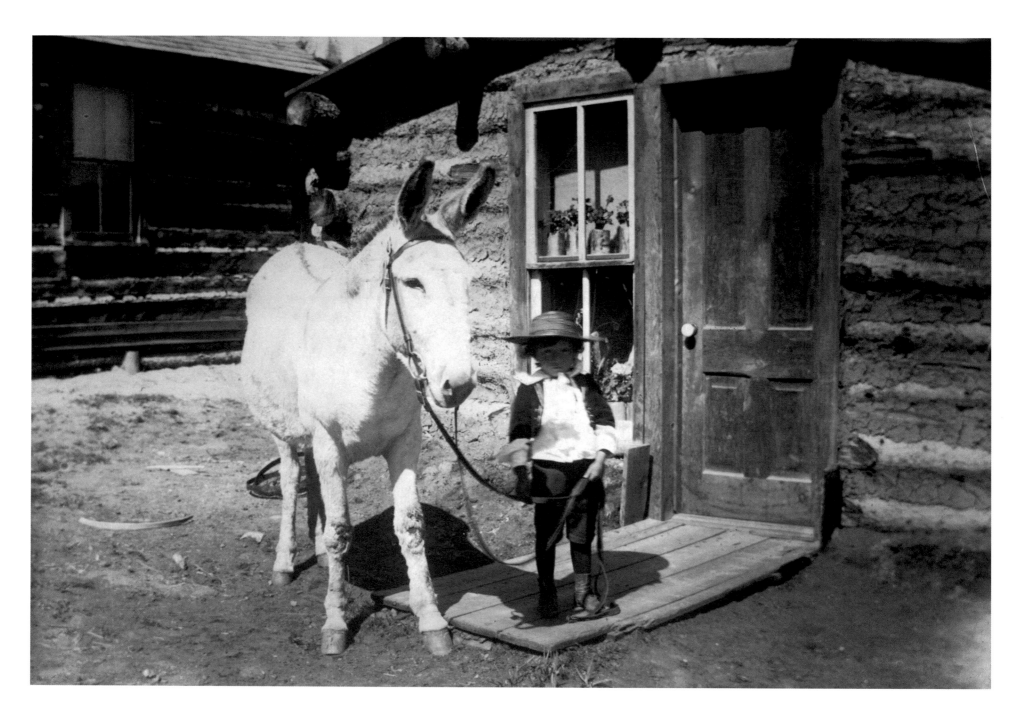

Boy and burro, Creede, 1896

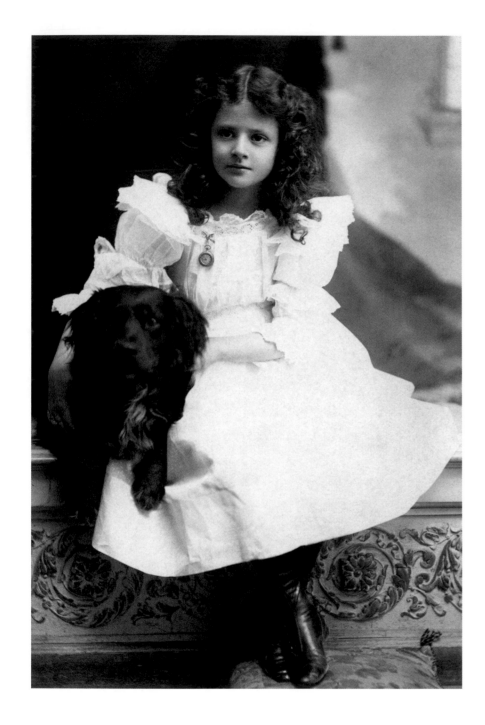

FREDA TASCHER, DENVER, C. 1905

GIRL WITH CAT, CAÑON CITY. **CHARLES E. EMERY,** C. 1890

Boy with dog (D. E. White family). **Oliver E. Aultman**, 1900

Phelps Collins, Jr., Collection, c. 1905

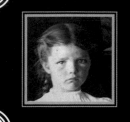# SCHOOL

More than anywhere else, school—at your desk, in the classroom—was where you belonged. You might try to resist it a few times by pretending to be sick or conspiring with your friends for just one day of freedom, but in the end it never felt good. Somehow it was better to be in school and look out the window, thinking of where you would rather be, than not be there at all.

Day in and day out, seated at your desk, you began to feel that you really did belong there, and although the halls and rooms belonged to the school, your desk was your own. It was rooted to the floor, and its flat, wooden surface bore the marks of all the students who had been there before you.

Even if you didn't like where you sat in the room, you somehow got accustomed to it and to the children who sat near you. Every year there might be a new desk, other children, and a different room, but you could remember everything about your old room even when you had forgotten an assignment from the day before.

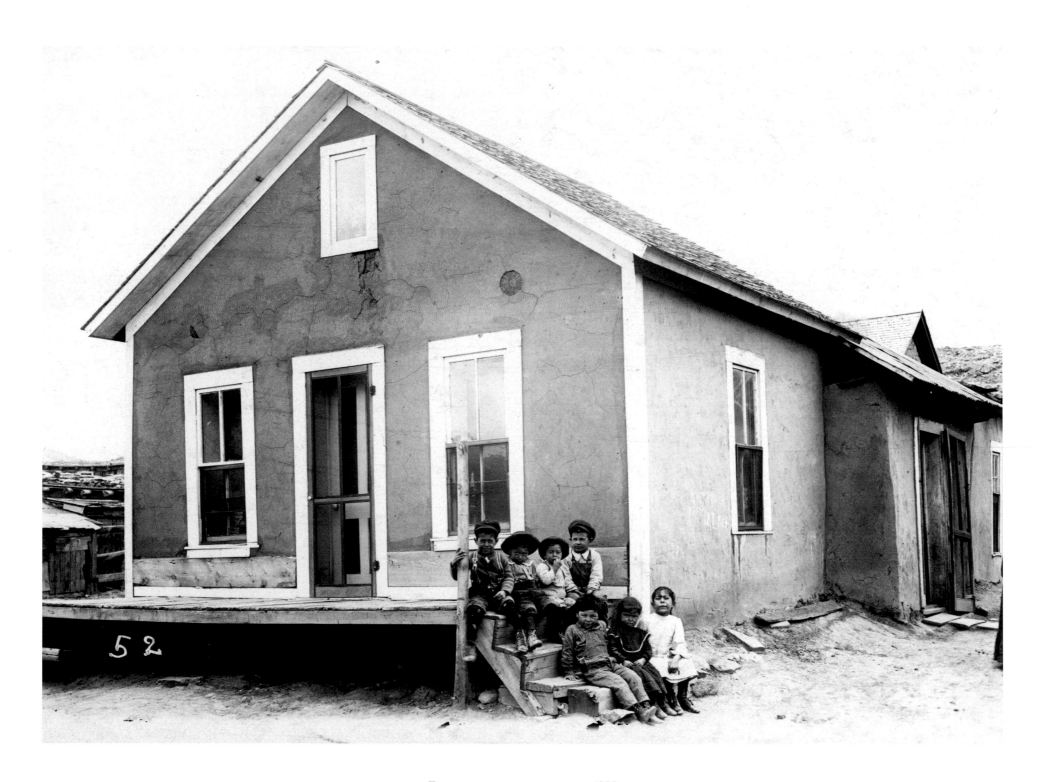

Trinidad area schoolhouse, c. 1900

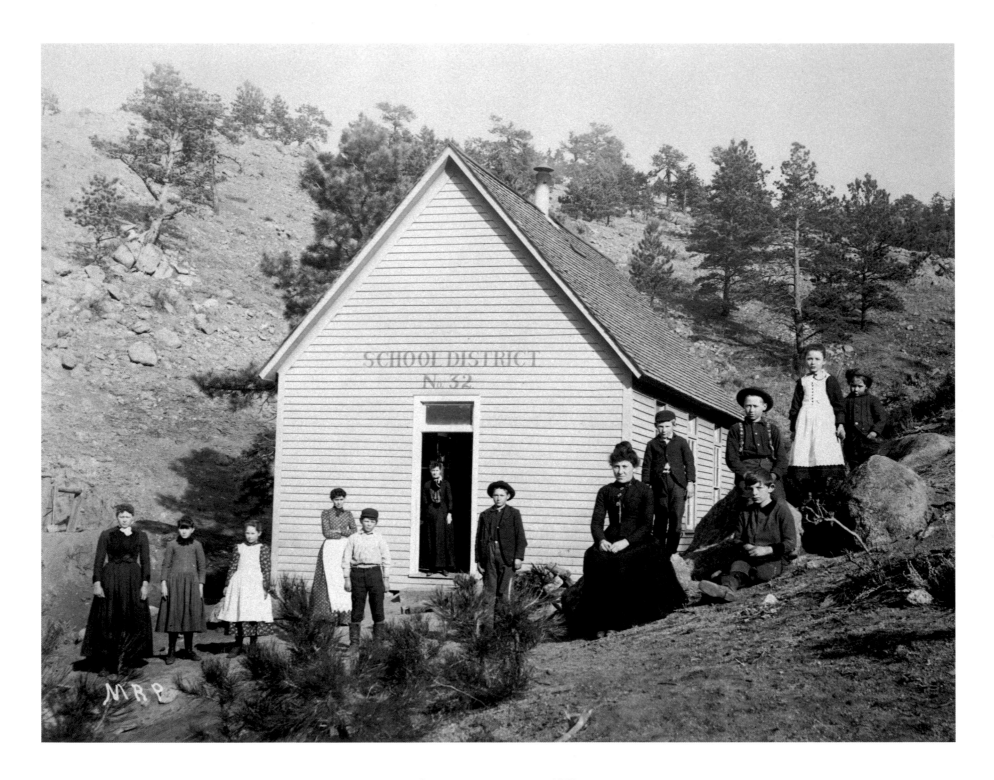

Crisman schoolhouse, c. 1885

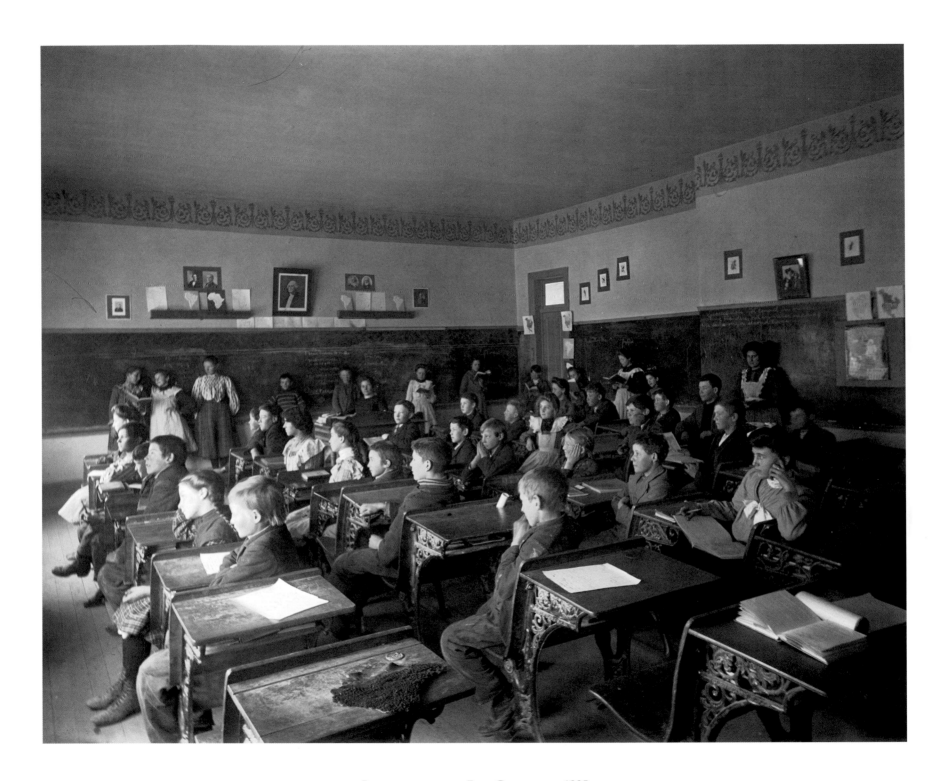

RIFLE SCHOOLROOM. **FRED GARRISON**, C. 1895

# PLAYGROUND

On the playground, you were not yet out of school but not quite in it either. Someone would always be watching, even from afar. You could run, but not too fast—you could play, but not too long. There was only enough time to do certain things, and if you had no one to share them with, well, you would just have to wander. But in wandering, you would discover very little, because the playground had nothing to offer but other children.

If, on the other hand, you had friends, there was always a place to meet—somewhere out on the most barren flat or tucked away in the shadow of the building. Every day it was the same thing, the same people, and usually the same place. Yet it was not boring, and often the very best time came just before the bell rang. Then all the playground was alive with one last skip of the rope, or whisper, or flick of a marble, and you would run back, still living the last moment, to your place in line.

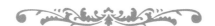

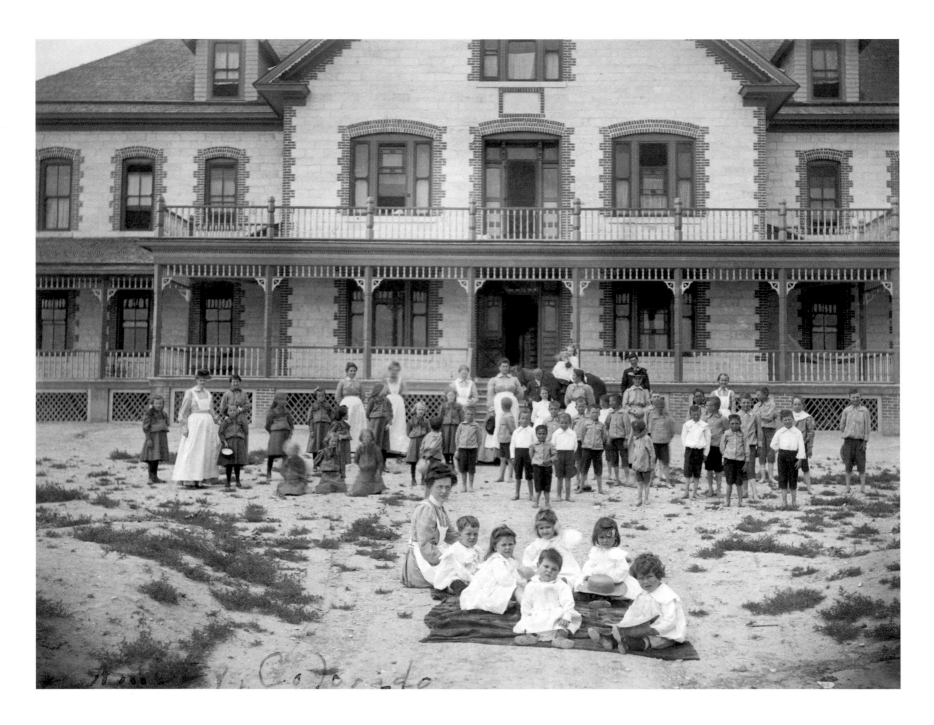

Fort Amity schoolyard, Amity, 1902

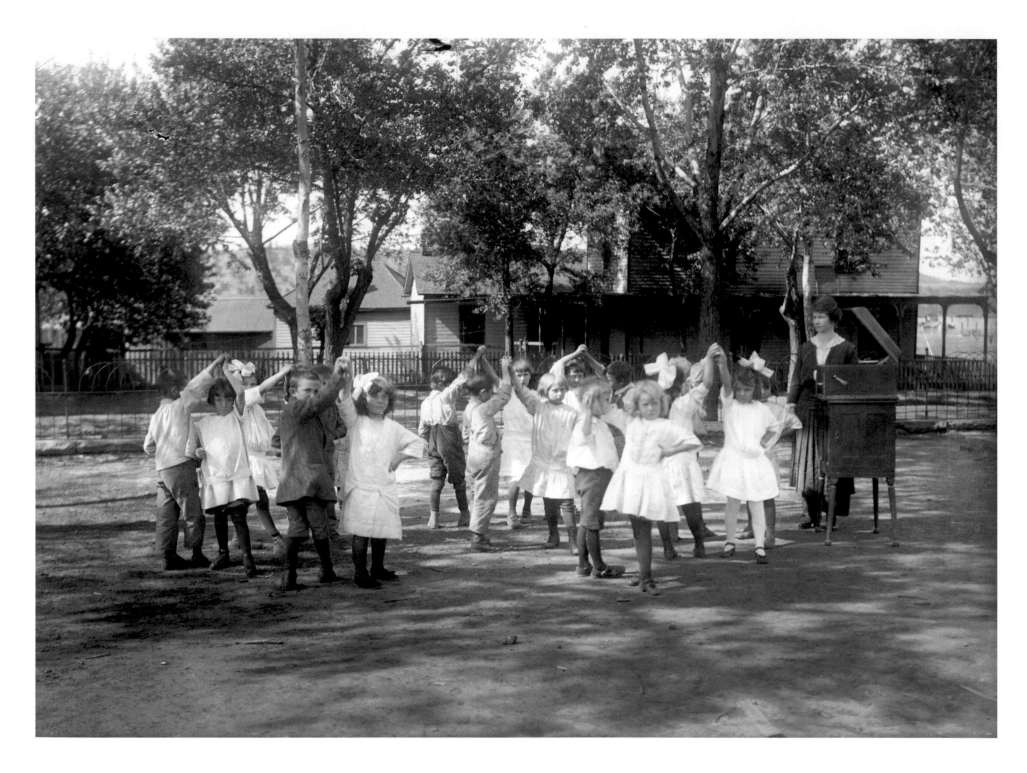

Sopris School playground, Sopris.  **Otis A. Aultman**, c. 1915

Calisthenics at Danforth school, Pueblo, c. 1910

# SCHOOLWORK

You were not expected to like doing schoolwork, so you seldom admitted you did. You might be surprised to find that penmanship, say, or arithmetic was actually easy—but then you would have to show your friends that this had nothing to do with how you really felt about it. For there was nothing worse than a person who liked doing schoolwork and did it well, too.

Usually, however, you could not count yourself among the best spellers and readers in the class, and the harder it was to do your lessons, the more you disliked them. But once in a while, good student or bad, you would look at your work and think that—for you—it was fine.

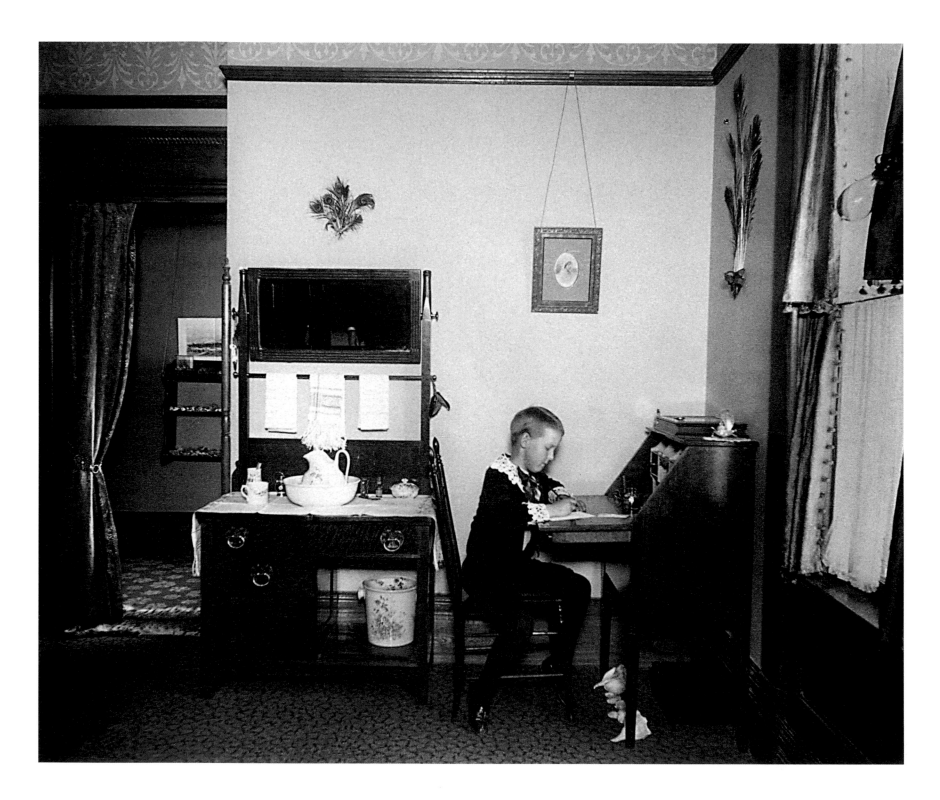

ARTHUR CHURCH, 1000 CORONA STREET, DENVER, C. 1905

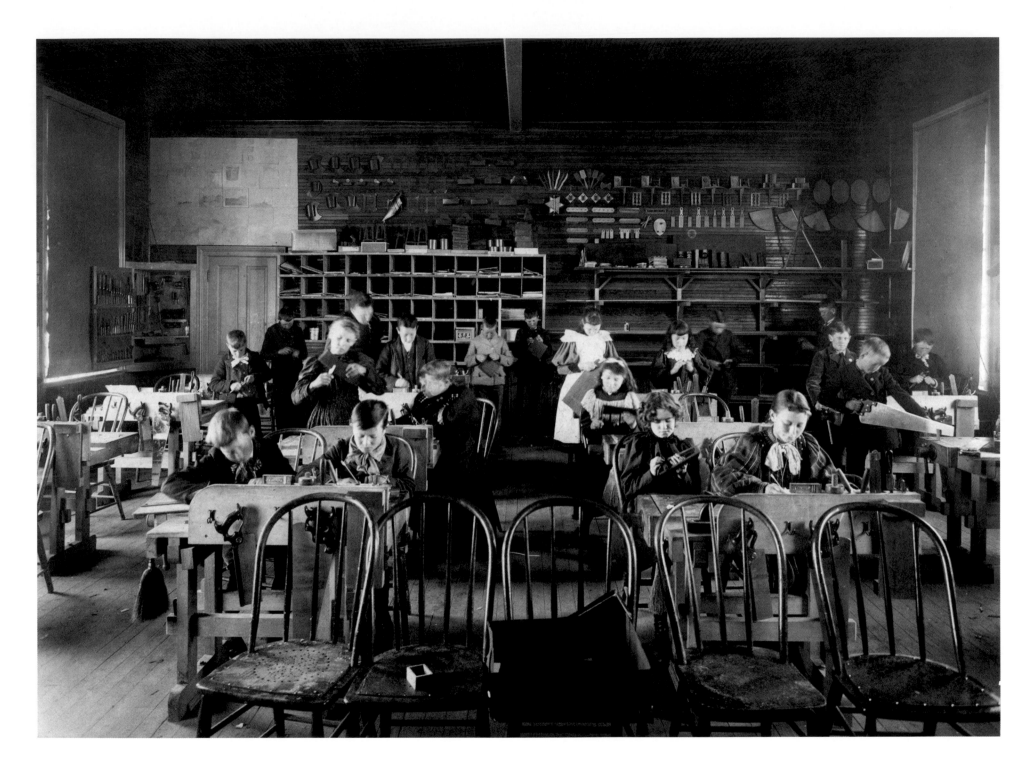

CRAFT WORK, DENVER.  **J. B. STANTON**, C. 1895

UNKNOWN GIRL, C. 1905                    GIRL WITH STAR OF DAVID (SOL JAFFA FAMILY).  **OLIVER E. AULTMAN,** MARCH 1890

AUDRY CAPOTA, C. 1890

MARY EDNA BURNS, COLORADO SPRINGS, C. 1885

Unknown boy, c. 1890

Unknown boy, Denver. **Everett R. Johnson**, c. 1915

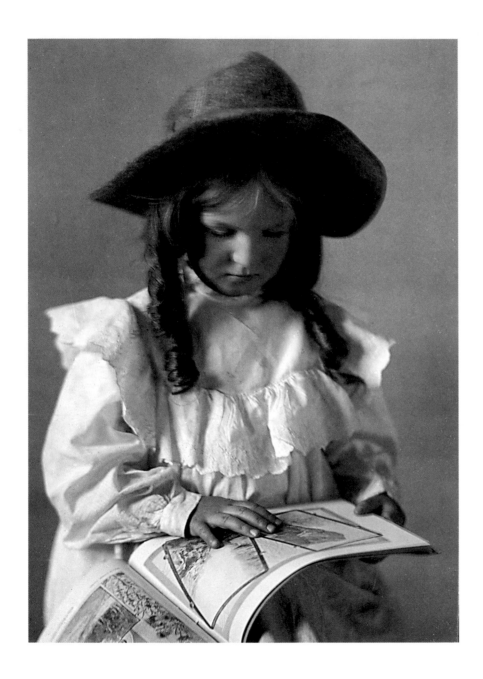

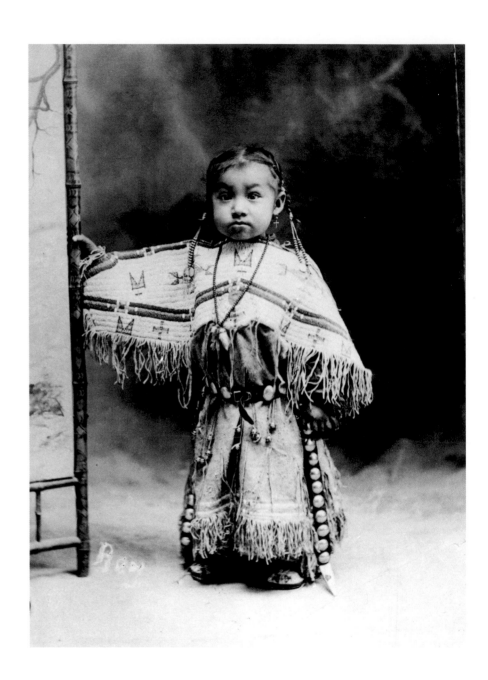

UNKNOWN GIRL, TRINIDAD. **W. L. CROUCH**, C. 1905

LAKOTA GIRL. **J. R. COLLIER COLLECTION**, DENVER, 1880S

EDGAR JONES, SAGUACHE, C. 1895

WILLIE ALYOOCH, DENVER. **ROBERT S. SOURS**, FEBRUARY 1891

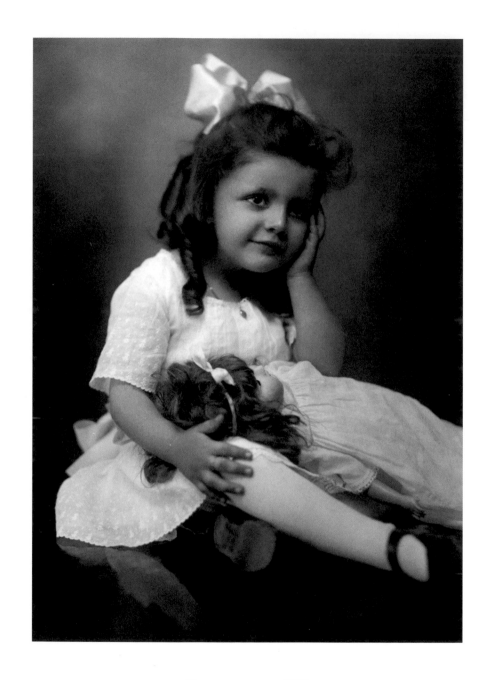

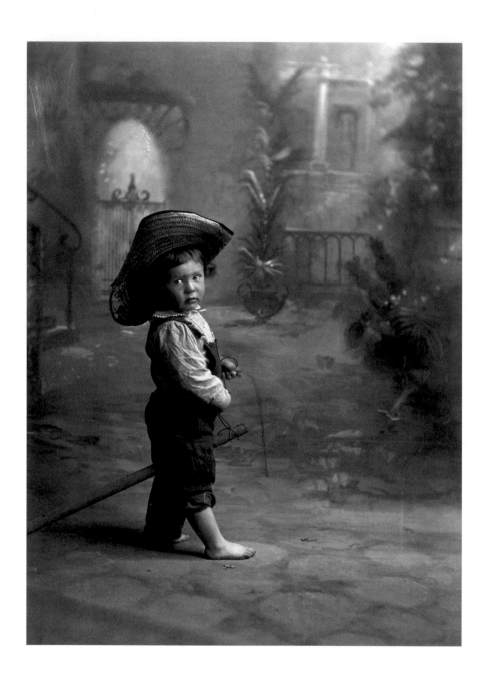

Unknown girl, c. 1905

Unknown boy (George Bateman family), Trinidad. **Oliver E. Aultman**, 1895

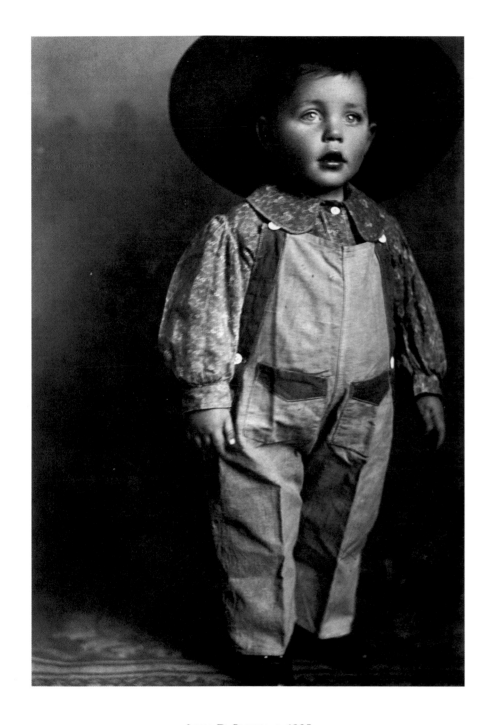

LEON D. PARGIN, C. 1905

RICHARD DOWNING, DENVER, JUNE 1901

UNKNOWN GIRL (KENNEDY FAMILY), RIFLE. **FRED GARRISON**, C. 1905

CAROLINE BANCROFT, DENVER, C. 1902

BERTRAM BACA, SON OF FELIX BACA, TRINIDAD, C. 1905

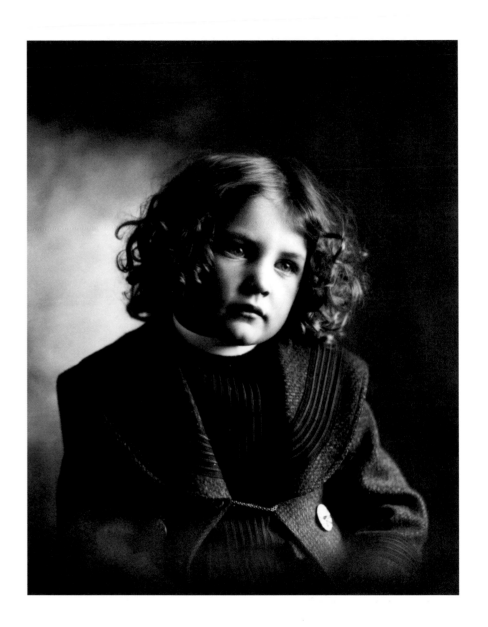

UNKNOWN BOY, 1890S

UNKNOWN BOY, CENTRAL CITY.  **MRS. V. M. KEPLER,** 1890S

GRACE SUGARMAN AS "TOMMY THE NEWS BOY."  **OLIVER E. AULTMAN,** 1897

Unknown boy, Rifle. **Ola Garrison**, c. 1910

John Evans, Denver, c. 1895

**International Standard Book Number:** 1-56579-475-3

**Text copyright:** David N. Wetzel for the Colorado Historical Society, 2002.
All rights reserved.
Historical photographs courtesy of the Colorado Historical Society

**Editor:** Kelly K. Anton
**Photo Processing:** Jay DiLorenzo and Michael Wren,
                        Colorado Historical Society
**Designer:** Mark Mulvany
**Production Manager:** Craig Keyzer

**Published by:**
Westcliffe Publishers, Inc.
P.O. Box 1261
Englewood, CO 80150
www.westcliffepublishers.com

**Library of Congress Cataloging-in-Publication Data:**
Wetzel, David N. (David Nevin), 1942-
  I looked in the brook and saw a face : images of childhood in early
Colorado / text by David N. Wetzel ; photos selected and edited by
MaryAnn McNair.
      p. cm.
"From the collections of the Colorado Historical Society."
  ISBN 1-56579-475-3
  1.   Children--Colorado--History. 2.
Children--Colorado--History--Pictorial works. 3.  Portrait
photography--Colorado--History.  I. Colorado Historical Society. II.
Title.
HQ792.U5 W434 2002
302.23'09788--dc21
                              2002024985

*For more information about other fine books and calendars from Westcliffe*
*Publishers, please contact your local bookstore, call us at 1-800-523-3692, write for*
*our free color catalog, or visit us on the Web at* **www.westcliffepublishers.com.**

**Cover Photo:** Children and Saint Bernard on South Platte River, Denver.
Charles Lillybridge, c. 1900

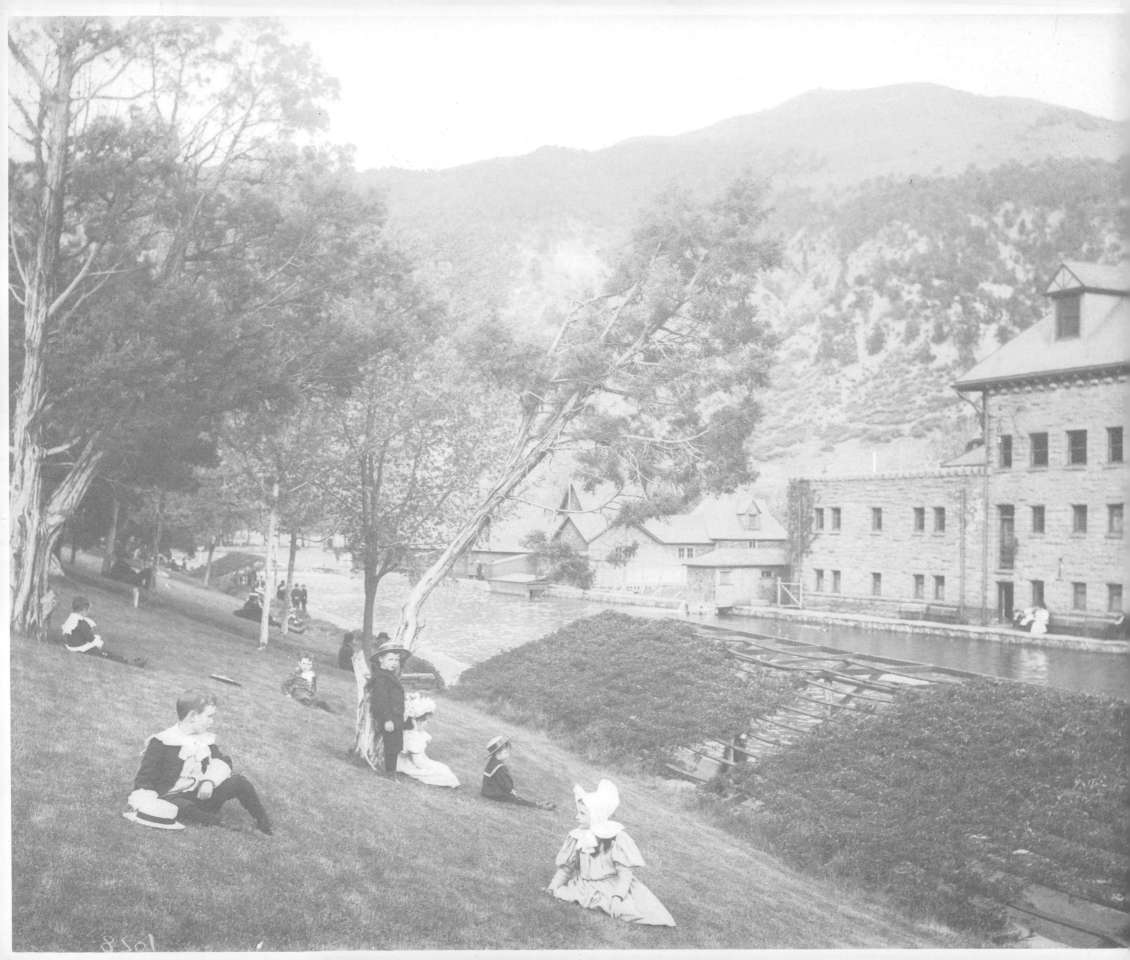